The Organic Artist for Kids

A DIY Guide to Making Your Own
Eco-Friendly Art Supplies from Nature

MAKE YOUR OWN
BRUSHES, PAINT,
CHARCOAL, PRINTS
& MORE

NICK NEDDO

QUARRY

Brimming with creative inspiration, how-to projects, and useful information to enrich your everyday life, Quarto Knows is a favorite destination for those pursuing their interests and passions. Visit our site and dig deeper with our books into your area of interest: Quarto Creates, Quarto Cooks, Quarto Homes, Quarto Lives, Quarto Drives, Quarto Explores, Quarto Gifts, or Quarto Kids.

Inspiring | Educating | Creating | Entertaining

First Published in 2020 by Quarry Books, an imprint of The Quarto Group,
100 Cummings Center, Suite 265-D, Beverly, MA 01915, USA.
T (978) 282-9590 F (978) 283-2742 Quarto Publishing Group USA Inc.

Quarry Books titles are also available at discount for retail, wholesale, promotional, and bulk purchase. For details, contact the Special Sales Manager by email at specialsales@quarto.com or by mail at The Quarto Group, Attn: Special Sales Manager, 100 Cummings Center, Suite 265-D, Beverly, MA 01915, USA.

10 9 8 7 6 5 4 3 2 1

ISBN: 978-1-63159-767-1

Digital edition published in 2020
eISBN: 978-1-63159-768-8

Library of Congress Cataloging-in-Publication Data available

Design: Rita Sowins / Sowins Design
Cover Image: Susan Teare Photography
Photography: Susan Teare Photography, except on pages 10 (bottom) and 120
Illustration: Nick Neddo

Printed in China

TO IRENE. Your influence on my creative development was monumental. You literally created the surface area for me to explore my potential and grow into the artist I am today. The love and quiet support you offered me has been my foundation all these years.

CONTENTS

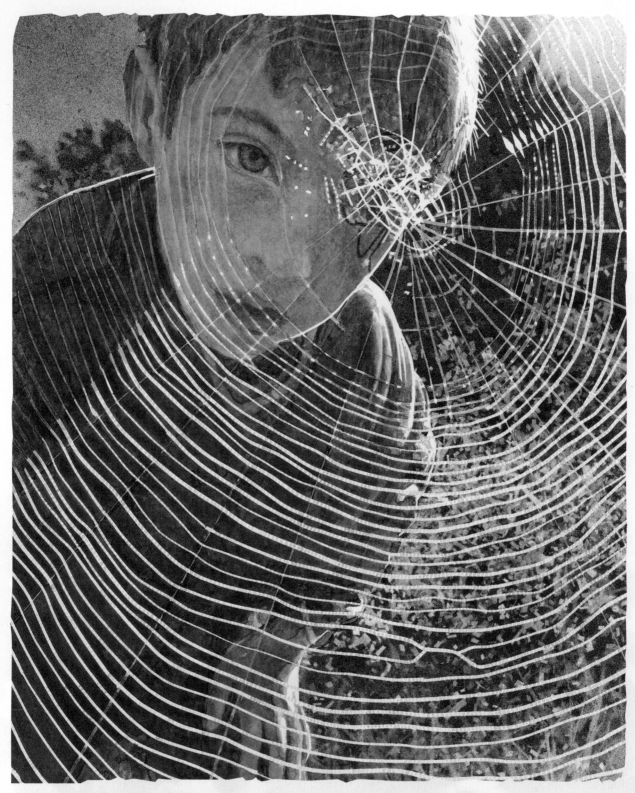

Kids are naturally curious and, with the right kind of support from adults early on, they will remain so throughout life. *Orb Weaver*, Nick Neddo, painting with ink made from willow bark.

INTRODUCTION

WHAT IS THIS BOOK REALLY ABOUT?

Mother Nature is my favorite artist. I surround myself with her art, and because she is the ultimate inspiration in my creative process, my studio is filled with treasures from the landscape.

This book is a guide for adults to introduce children to the process of making art with nature's materials, as well as creating art-making tools by hand. *The Organic Artist for Kids* is about fun and creativity, which, when combined, leads to learning. What will you learn from the projects and exercise in this book, you may ask? These projects guide you to:

- Be resourceful
- Be creative and experimental
- Become more nature-literate
- Improve your skills as an artist
- Develop skills with hand tools
- Be more confident
- And, of course, develop and maintain a healthy connection to your own unique creative process

Some of the projects in this book are fairly simple and accessible to the youngest among us, and some are more involved, requiring adult supervision. Each project is marked with one, two, or three oak leaves to give you a sense of how accessible it is for a certain age or skill level. Look for the leaves at the beginning of each project.

ROLE MODELING AND MENTORING

This book gives kids responsibilities and does not insulate them from valuable learning opportunities. Yes, it is about making art and art tools from nature. It is also about empowering young people with new skills as well as knowledge of nature and the secret life of their local landscapes. In the past twenty years of

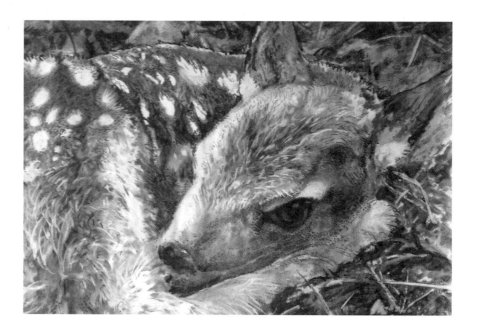

A large part of a healthy education early in life involves a lot of play, rest, and repeat. *Summer Fawn*, Nick Neddo, drawing with charcoal made with willow.

teaching kids and adults wilderness skills and nature literacy, I have become aware of how many young people are never taught how to use basic hand tools because of the fear of injury. The irony of this is not lost on me, because the biggest danger in using sharp tools is the lack of experience and quality instruction from a mentor. In the following pages I lay out my standards for safe knife and fire use (two of my favorite tools that are directly applicable to some of the projects ahead) for you to practice and teach.

PLAY

Let's not lose sight of the developmental value that play has in young lives. There are good reasons why play is a universal behavior among the world's young creatures. Even when a mother bear struggles to find enough food to feed her cubs in hungry times, she tolerates what seems to be a waste of precious calories by her little ones.

Play is the original form of school. In the early years of our lives we learn so many of our foundational skills through the process of playing. We acquire body awareness and coordination, communication skills and awareness of social dynamics, problem-solving skills, and adaptability, just to name a few. Being playful is great for learning. When we are in a state of play (or relaxation), we can

experience curiosity followed by experimentation and oftentimes creative breakthroughs.

SETTING UP A CREATIVE ART SPACE IN YOUR HOME

Whether you live in a tiny house or a mansion, you need to designate a space for art and handcrafting. If you have a room for this, awesome! If not, it can be a corner of the living room or closet—a place where there is a flat work surface and space to keep supplies like paper and pencils. Ideally, this can be a space that doesn't always need to be cleaned up immediately afterward, but if not, so be it. I think of the experience of "being creative" as somewhat sacred. It is a special kind of mind-set that comes and goes, like a friendly guest who is a lot of fun to have around. When we have a place at home for drawing and painting and making stuff, it is like we are extending a warm invitation to that special guest, Creativity. Notice when your kids are being creative and don't let trivial things interrupt them. One of the greatest things anyone did for me in my childhood was making sure I never ran out of paper to draw, sketch, and doodle on. Thanks, Gramma.

GATHERING RAW MATERIALS FROM THE LIVING LANDSCAPE

In general, Mother Earth's life-forms are resilient. But in today's world, nearly all life-forms are dealing with stress from all directions. It is our responsibility to not be part of this problem as much as possible and help ensure the health of the ecosystem.

Protecting and caring for a place on the landscape is as natural as breathing. The desire to help a place heal or stay healthy is a natural result of feeling gratitude toward that place. This kind of gratitude comes from getting to know that place, which comes from spending quiet time there and becoming part of it. It is no surprise that many people who are not given the opportunities or are unable to spend time in undeveloped places don't develop a profound sense of belonging or a desire to preserve those places. It doesn't need to be "wildernesses." You can find this connection in pocket parks, your backyard, or even a strip of forgotten grass between buildings.

Being still in nature promotes a deeper sense of self and connection with life in general. *Bird in Hand*, Nick Neddo, felt-tipped pen.

Inky Cap, Nick Neddo, ink drawing and painting with ink made from inky cap mushroom, *Coprinus comatus*.

OUR HUMAN SUPERPOWERS

Our biggest superpower is creativity. Think about how long we humans have been living on planet Earth as *Homo sapiens*. We have been around for at least 200,000 years, although new findings are pushing that date back to 300,000 and possibly earlier.

Our Stone Age ancestors solved all of their problems without the use of metal, plastic, paper, glass, or electricity. They relied on wood, bone, antler, stone, ivory, shell, and other materials from the natural world to provide for literally everything they needed. Imagine if you had to make everything you own from scratch. Even with access to modern materials, this is not easy. Not only that, but thanks to our ancestors we inhabit every climate on Earth and survived through mega droughts and ice ages. If our ancestors weren't super smart and creative, we wouldn't be here today.

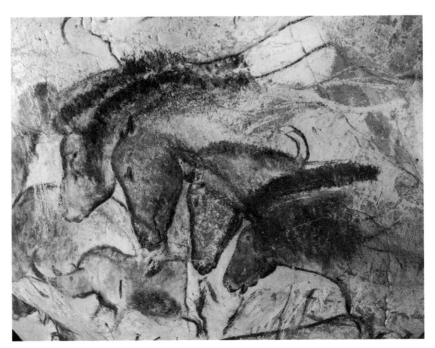

Some of the earliest known human artwork discovered in the Chauvet Cave in Southern France.

HANDS

Our most powerful creative tools might be our hands. Think about all the amazing things they can do! We use our hands almost every moment of every day, and it is easy to take for granted how much we depend on them. In many ways, this book is a celebration of our hands and their beautiful power.

ABOUT THE ARTWORK AND ILLUSTRATIONS

All of the artwork presented in this book is made from handmade materials from the landscape, unless noted otherwise. My hope is that the artwork inspires readers of any age to explore the creative potential of the projects presented in this book.

- Improve skills as artists
- Develop hand-eye coordination and skills with hand tools
- Be more confident

When it comes to how we spend time with kids, the future is literally in our hands. *Touch the Future*, Nick Neddo, painting with paint made from stones.

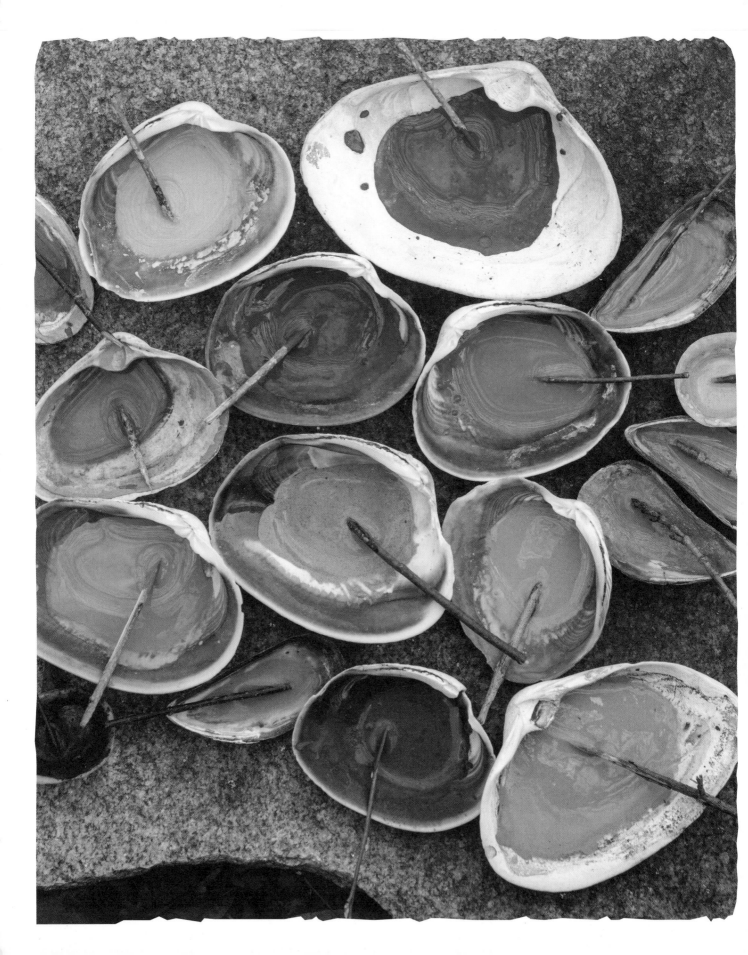

PAINT

One of the great joys in life is adding color to an object or a surface. This chapter explores the process of making paint as our ancestors did in Stone Age times.

We human critters have been painting for a long time. The earliest known figurative paintings are found in Indonesia and were made about 35,000 years ago, during the Ice Age. But people were painting way before then. In South Africa, a 100,000 year-old (!) workshop was found, where people turned stones into paint. Ancient paint-making tools were found in Zambia from even deeper in prehistory: 400,000 years ago! Our extinct human cousins were painting before our species, *Homo sapiens*, even existed!

Our Stone Age ancestors spent a lot of time and energy making their paintings. We know it was important to them based on the skill and effort they put into their work and the support they had from their community. Why do you think it was so important to them?

SIMPLE STONE PAINT

CHALLENGE LEVEL

MATERIALS
· Stones

There are many kinds of paint, but they all have two things in common: they are made from a pigment and mixed with a binder. You will learn more about those as you work through the projects in this chapter. This project is a perfect place for kids to start. It is the most "wild" paint, and it will lead you on an adventure to make it!

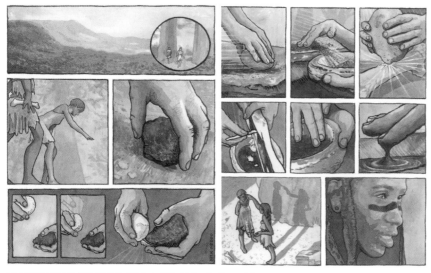

The Paint Makers, Nick Neddo, pine soot ink and red ochre paint.

A wide assortment of stones for pigment experiments can often be found along natural waterways.

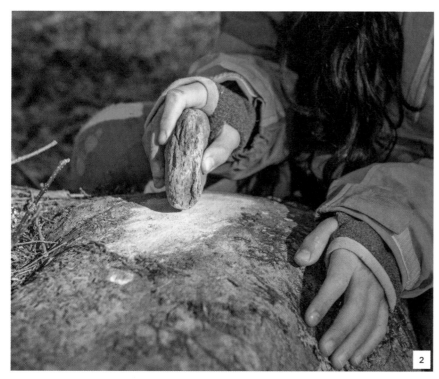
If a rock can draw a line like chalk, it can make pigment and paint.

1: FIND A NATURAL WATERWAY WITH STONES

When it comes to making paint from rocks, some of the very best places to look are a stream, brook, river, lakeshore, or rocky beach. These are the places where nature has collected the most interesting varieties of rocks.

2: TEST OUT SOME ROCKS

It is possible to make pigments from any rock, but the question is: How hard do you have to work for that to happen? The pigment test is quick. First, pick up a rock that can fit into the palm of your hand and see if you can draw with it, like using chalk. It is a good sign if it leaves marks on other rocks!

3: GRIND THE ROCKS

Next, find a larger rock to use as a grinding surface. Hold the first rock firmly as you grind it back and forth on the larger rock. Spend about ten or twenty seconds grinding, adding more pressure as you go. If the stone that you are testing leaves a small pile of powder, it passes the test (this is "rock science," not rocket science).

Binders

A binder is an ingredient that you add to pigment to make it into paint. It changes a pile of colorful powder into something wet and a little sticky and keeps the pigment particles suspended in liquid. Mixing pigments with water isn't good enough because the water is too thin and the pigments settle to the bottom of the container. Binders also help paint stick. Without a binder, dried paint can be brushed off the surface with your hand when it dries. You can use the same exact pigments with five different binders and end up with five different kinds of paint. Some examples of traditional binders are eggs, glues, drying oils, tree resins, and gums.

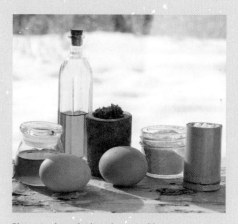
Pigments give paint its color, but without something to mix with and stick to, it's just a bunch of colorful powder.

Pigments

Pigments give things color; you can thank them for every color that you have ever seen (the cones and rods in your eyes deserve a shout-out too).

When it comes to making your own pigments, there are two general categories: pigments from rocks and pigments from life-forms (plants, animals, and fungi). When pigments come from rocks, they are a fine powder; from plants and fungi, they're usually a dye. In general, stone pigments don't fade over time, but the biological ones do. Think of a maple tree's leaves and how the colors change over the summer and fall. The pigments in the leaves break down and the colors change from greens to reds, oranges, and yellows, and then to browns until they turn back into soil.

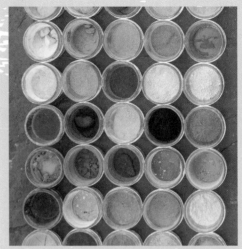

ABOVE RIGHT: Pigments processed from stones can be stored in jars until you want to use them.

RIGHT: Nature is full of pigments; some are more permanent while others fade and decompose, like autumn leaves.

4: SPIT IN THE PIGMENT

Human saliva is a really good binder for paint and you won't be the first person to use it that way. Carefully let a drop of saliva fall directly onto the pigment. Try not to blow the pigment away as you do this! Now use your finger (which is also a great paintbrush and palette knife) to stir it in with the pigment. Guess what? You just made paint!

TIP: Be sure to bring water to drink on this adventure. In addition to keeping you alive, it will help replace the saliva you are donating to the paint.

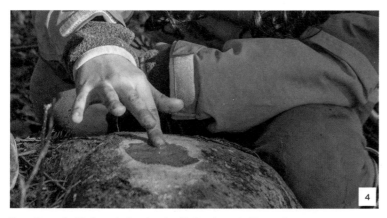

Use saliva as the binder and mix a drop in with the pigment with your finger.

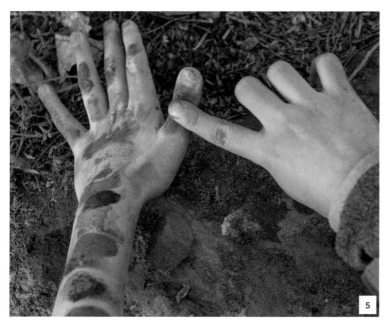

Test out your paint on a nearby object, like your arm.

5: PAINT SOMETHING

This simple paint (some call it "spit paint") is great for using on your own skin (your spit = your skin). I like to finger paint a little stripe on my forearm to test the paint and get an idea of what the color looks like after it dries. Repeat this with a bunch of other rocks and before long you might have a whole sleeve of colors decorating your arm! You can also decorate something else, like a large rock, a stick, or even a tree's bark. Or hey, bring some paper along! This kind of paint will wash off easily.

Playing Around: Painting with Mud

If you find the right mud puddle it can be a perfect "paint pot." First, it has to be on natural soil, not pavement or concrete. And it has to be nearly dried up, with just a bit of water left. Stir the top layers of fine mud (pigments) with the water and paint directly from the puddle. Or collect some of the fine upper layers of mud in a cup or jar and add a little binder (honey, perhaps) and paint away!

PROJECT ⋮ 2 ⋮ EARTH PIGMENTS

The tools and techniques to make fancier paint are simple, and were even used in the Stone Age by our artsy ancestors. To make better paint, we need to focus on making more pigment. The following project is the foundation for making different kinds of paint and even color crayons from rocks.

CHALLENGE LEVEL

MATERIALS

· Rocks

TOOLS

· Scrap piece of cloth
· Hammer
· Stone mortar and pestle
· Clear glass jars
· Canning funnel
· Fine-mesh filter (tea strainers work well)

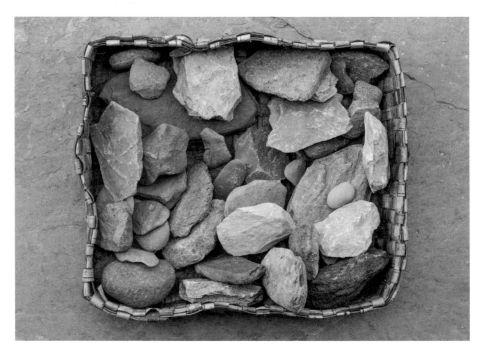

Rocks offer an assortment of colors for the paint maker.

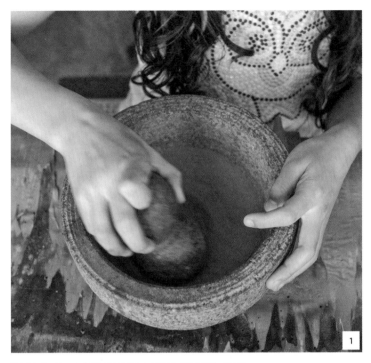

Start out with small stones and break them down into gravel.

TIPS: Wear eye protection and a dust mask while you are processing pigments, especially large amounts.

Work in a well-ventilated area, like outside.

Work with small batches instead of trying to grind too much at once.

1: BREAK LARGER STONES INTO SMALL STONES

If the rock is bigger than a Ping-Pong ball, it needs to be broken up. Bring it to a hard surface (like a larger stone) and cover it with a piece of fabric. Use a hammer to hit the stone through the fabric. If it doesn't break after a few whacks it is too hard for the mortar and pestle.

2: TAP STONES INTO GRAVEL

Gather soft stones (see Project 1) and bring them home to your workspace. Set up outside if it's nice out, or use a range hood or fan in the window if you have to be inside.

Choose small stones to begin with. Place a rock about the size of a marble in the mortar. Tap the rock lightly with the pestle. Continue tapping, each time a little harder, until the rock breaks open. Now tap on each piece until it breaks into gravel.

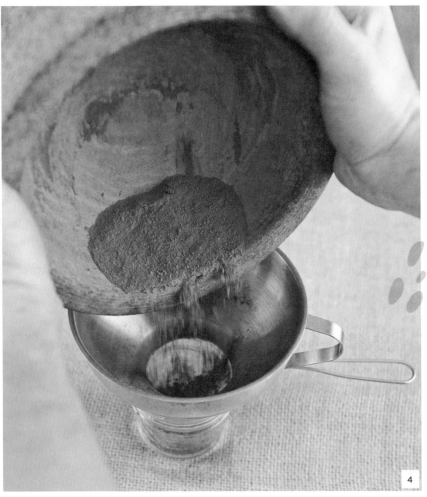

Collect your pigments in a jar.

3: GRIND GRAVEL INTO POWDER

Use the pestle in a circular motion with downward and outward pressure to grind the gravel into sand. Keep grinding until the sand turns into powder. The goal with this step is to make pigment that is as fine as flour. When you think you might be getting close, put your fingers in the mortar and feel the texture at the bottom of the bowl. If it feels sandy, keep grinding.

4: COLLECT YOUR PIGMENTS IN A JAR

When you are happy with how fine your pigment is, pour it into a jar through a funnel. Hold up the mortar while you use your fingers to sweep the pigments into the funnel. The stone mortars and pestles can be pretty heavy for little kids, so it might be best if older kids do the heavy lifting while younger kids do the "sweeping." If there are still some larger particles of stone, use a fine-mesh filter to sift them out when you are pouring the pigment into the jar.

TIPS: You can make a rich, black pigment from charcoal (see Projects 10 and 11). Process it in the same way as you do with stones.

Take your time and enjoy being part of a long tradition of paint making.

Super Fine Trick

If you want to make super-fine pigments, try this cool trick from the Stone Age. You only need a little bit of water and two jars with lids.

- Put your finely ground pigments in one of the jars.

- Then, add just enough water to cover the pigments.

- Put on the lid and shake it up for a few seconds. When you stop shaking, the bigger pigment particles settle to the bottom first, leaving the finer ones swimming around in the water.

- Collect the fine pigments by slowly pouring the liquid into the other jar, leaving the sludge in the bottom of the first jar.

The stuff you poured off is ready to be mixed with a binder, or it can be set aside to dry. Now you have some super-fine pigments!

PROJECT ⸪ **3** ⸪ # EGG TEMPERA PAINT

CHALLENGE LEVEL

MATERIALS

- Egg
- Pigments
- Water

TOOLS

- Jars
- Toothpick
- Paintbrush or stick

Egg tempera is a paint made from pigments, a little water, and egg yolk as the binder. It dries quickly and it can last for at least 3,500 years! It has a colorful history, going as far back as ancient Egypt, where it was used to paint tombs and mummy portraits. Tempera is easy to make and it's one of my personal favorites.

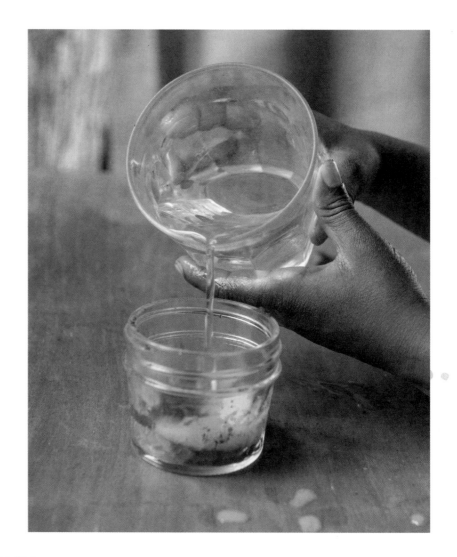

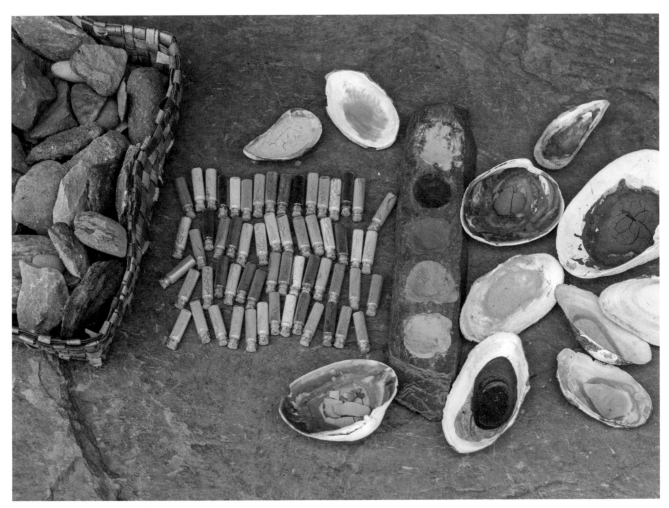
An assortment of paint dishes for storing and using handmade paint.

Playing Around: Experimenting with Binders

Now that you have some pigment it is time to make it into paint. In some ways this is like mixing up a magic potion to paint with. The following projects show you how to make different kinds of paint from your earth pigments, using various ingredients as binders.

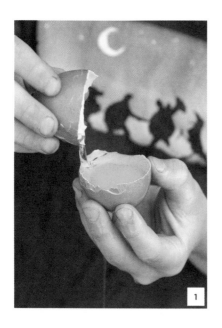
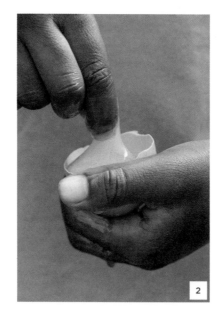
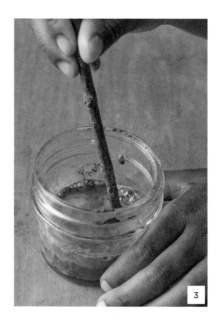

1: SEPARATE THE EGG YOLK FROM THE EGG WHITE

Find a chicken. Okay, we can skip ahead a little. Crack open an egg, ideally leaving the shell in two nice halves. It is only the yolk of the egg that we want. The whites won't ruin it, but the consistency can be kind of snotty. Pour the yolk from one shell half to the other, holding them over a bowl. The idea is to get the egg white to separate from the yolk and drip out as you carefully pour the yolk from one half to the other.

2: PREPARE THE BINDER

Egg yolks are like little yellow water balloons with slimy skins. With the yolk still in the shell half, carefully pinch it and pick it up slightly by its skin. Hold it above a container (a jar or the other half of the eggshell) and puncture it with a sharp stick (perhaps a toothpick) to release the juices, catching them all in the container. Pull off the skin from around the yolk and get rid of it.

3: COLOR THE YOLK

Add some pigment to the yolk, about 1 part pigment to 1 part egg yolk. Use a twig or paintbrush to stir them, using the eggshell as your paint dish (you can transfer this all to a jar or other container if that's easier). Add only a little bit of pigment at a time so the paint doesn't get too thick and paste-like. Next, add some water to the pigmented egg yolk. This helps keep the paint from drying out too quickly. Go for about 3 parts water to 1 part egg/pigment. Stir it well.

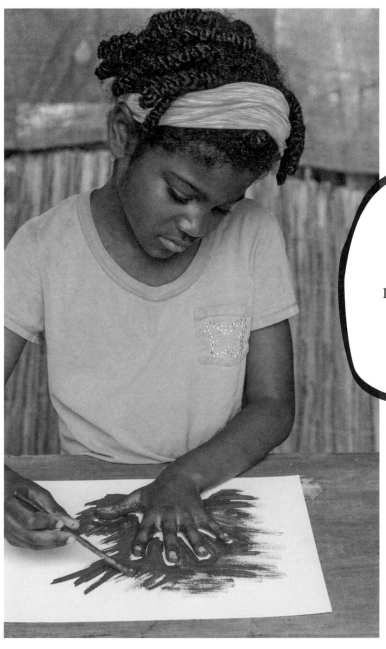

TIP: This kind of paint is called tempera paint. It lasts forever when it's dry, but has a very short shelf life before then. Mix up small batches at a time. If you make more paint than you need, add a few drops of vinegar and store it in the refrigerator, where it will last for a few days. You only need to smell bad egg tempera paint once in your life to learn this lesson!

What are you waiting for? Paint something!

PROJECT ∶ **4** ∶ # WATERCOLOR PAINT

CHALLENGE LEVEL

MATERIALS

- Pigments
- Water
- Honey

TOOLS

- Jars
- Stirring spoon
- Eyedropper
 (optional)

Any binder that dissolves in water can make watercolor paint. Traditional watercolors are made with gum arabic, the magical sap from acacia trees. This stuff is awesome and you can get your hands on some from an art supply store. Because we're focusing on ingredients that are easier to get your hands on, we'll use honey as the binder in this watercolor paint.

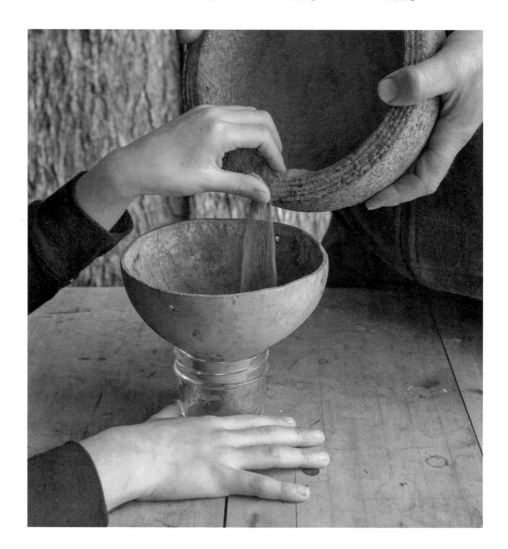

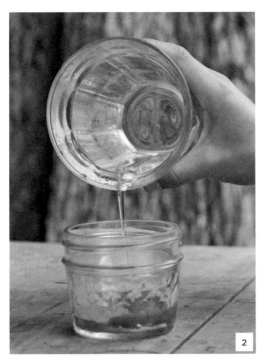

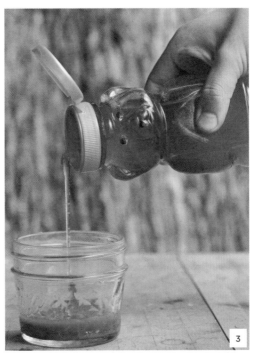

Add a little bit of water to the pigment and stir well.

Next, add a little honey as the binder.

1: SET UP THE PAINT POT

Put a little bit of pigment in a small jar and get some water and honey. This will be your mixing bowl and paint pot all in one. Start out with a small batch: go with about 2 teaspoons.

2: MAKE COLORFUL MUD

Add a little bit of water to the pigment, something like 1 part water to 1 part pigment by volume. Add small amounts of water at a time and stir until the mixture looks like mud. Be careful not to add too much water. It's hard to take it out if you have too much. For younger kids, you may want to use an eyedropper.

3: ADD HONEY

Start out by adding about 1 part honey to 5 or 6 parts colored mud. The amount of binder to add is not an exact science, so don't get too hung up on measurements. It comes down to personal preference in how you like your paint. If you want thicker paint, add more binder; for thinner paint, use less binder. With honey it is better to have too little rather than too much.

TIP: If the honey water-color paint dries a little sticky, you can sprinkle pigment on it to fix the problem. Just match the paint to the pigments they are made from and add less honey next time.

Playing Around: Using Other Binders in Your Watercolor Paint

WHITE GLUE

This makes a paint that behaves similarly to both acrylic paint and watercolor, depending on how much water you add. Commercial glue used to be made from animal proteins called collagen (which is where gelatin comes from too). These days the most common crafting glue is white glue (or PVA glue), which is nontoxic. It works well as a binder and is a convenient option for making paint quickly from earth pigments, especially for younger kiddos, and most households have a squeeze bottle of it kicking around. Use it with water, and in the same ratios that you would with honey (see page 27).

GELATIN

Most grocery stores sell unflavored, undyed gelatin in little boxes. One little box of gelatin will last a while because you only need a little bit for each batch of paint. Use about 1/2 teaspoon of powder to 5 or 6 teaspoons of paint/water mix, using hot tap water to mix.

SUGAR AND MAPLE SYRUP

What do these all have in common? Okay, what else? Like honey, they are sticky and water soluble! These are the traits you want your watercolor binders to have. Have fun with these, just don't add so much that the paint dries sticky or else you might be feeding the ants your artwork. A little bit of these binders goes a long way. If you don't mix too much in with the water, these make a pretty sweet binder for your paint.

SOAP

A drop of liquid soap in water is fun to experiment with. A little bit goes a long way!

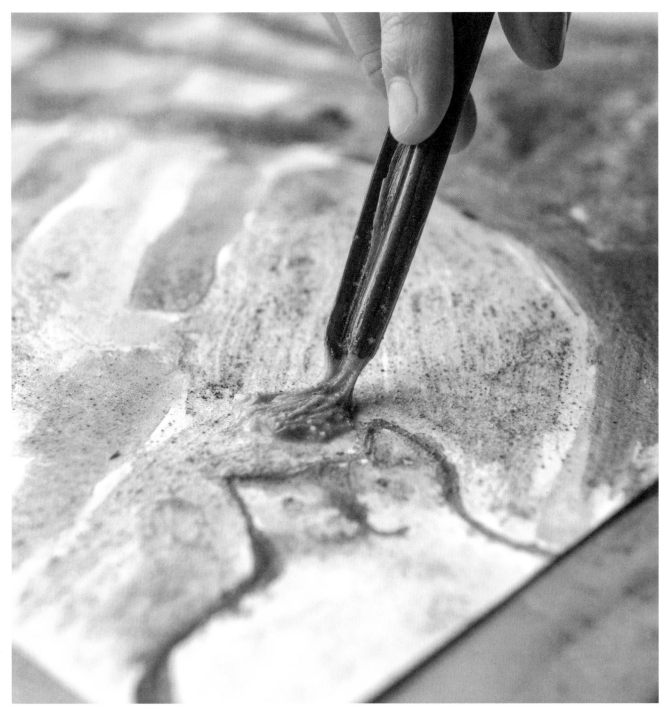

Using handmade paint is fun and uniquely satisfying.

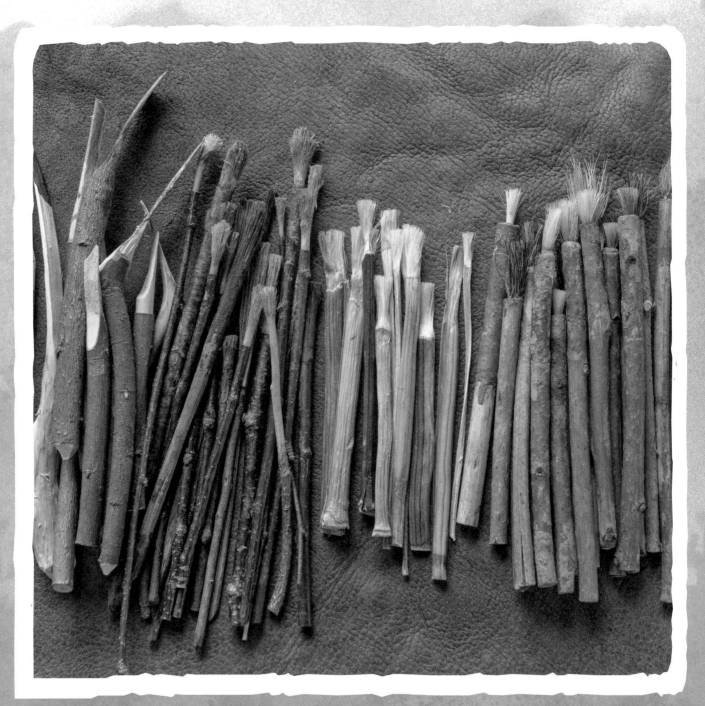
Paintbrushes are universal tools and can be considered works of art themselves.

PAINTBRUSHES

What do all paintbrushes have in common? Other than a handle, most of them have bristles, but all of them are tools for putting paint on a surface. Paintbrushes have been around since people have been putting their fingers into paint.

Paintbrushes of some sort are at least as old as the earliest paintings. These were made around 35,000 years ago by artists living in the Stone Age. Animal bones, sticks, leaves, and splinters of wood are some of the things people were painting with back then, but we don't really know what most of their paintbrushes looked like, or how elaborate they actually were.

Modern-looking paintbrushes may have first been developed in China around 1,300 years ago, but nobody knows for sure. In those times, they were often made with animal hair bristles and bamboo handles. They were used with ink for writing and to decorate pottery. By the fourteenth century, the time of Italian master Cennino Cennini, the paintbrush as we know it had spread all over the world.

In this section we will explore some fun ways to make paintbrushes from nature's bounty.

PROJECT ⁙ 5 ⁙ PAINTBRUSH SCAVENGER HUNT

CHALLENGE LEVEL

MATERIALS
- Paint
- Paper

There are a lot of variations to the common paintbrush, but some of my favorites are homemade and simply picked up from the landscape as found objects. For this project, all you need is some paint, some paper, and a sense of adventure! The goal is to experiment using different objects you find in nature as paintbrushes. I will give you some ideas to start out with, but don't worry—I'll let you make your own discoveries too!

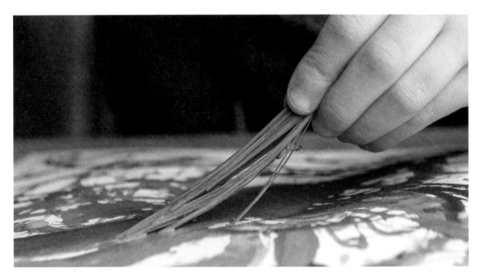

For creative hands, many things can be used as a paintbrush.

Playing Around: Experiment with Mark Making

How many different kinds of marks can you make with one hand? Make a collection of all the different marks and make up names for each one if you want!

PINE NEEDLES

Some people think that any tree with needles is a pine tree, but true pines (*Pinus* species) all have long needles compared to the other needle-leaf trees. These long needles (1 inch [2.5 cm] or longer) make natural paintbrushes that are ready to work with immediately. Find a twig that has a small cluster of needles at its end. The needles will be the bristles and the twig can be the handle. You can also use a small bundle of needles as a paintbrush without the twig handle. Just line up all the tips of the needles and grasp the other end.

DANDELION BLOSSOMS

The fresh blossoms of dandelions (*Taraxacum officinale*) can be used as a spongy paintbrush just the way they are. Dip them in your paint and see what you can do!

FEATHERS

Feathers come in many shapes and sizes and can be a lot of fun to experiment with when painting. Some feathers have a sharp point on the end; others are more rounded and flat. Big feathers are great for making broad brushstrokes and small ones can be used for painting intricate details. Keep your eyes out for these treasures when you go outside!

BERRIES

Have you ever tried to paint with a fresh berry? You might be pleasantly surprised by how well they work. Each berry has its own paint built in. When one runs out of "paint," just replace it with another berry. I have had a lot of fun playing with mulberries, blueberries, raspberries, blackberries, and even elderberries.

TIP: When painting with your fingers, keep a bucket of rinse water and a hand towel nearby so you can change colors without mixing all of your paint together.

Playing Around: Painting with Found Objects

Can you think of anything else in nature that has things that look like bristles? Keep your eyes and creative mind open to see what you can find!

Make a painting using at least three different found objects as your paintbrushes. See how many different kinds of brushstrokes you can get with each found paintbrush. Don't worry about what you paint. It can be abstract and experimental or it can be a painting of something in your imagination!

Knife Safety Standards

The things you can make with a sharp pocket-knife are endless. There are many special tools for doing all sorts of cool things, but in my opinion we should learn to do as much as we can with a simple knife. If you can use a single tool (rather than a whole mess of them) to make something, then you are winning.

Knives can be dangerous tools in the hands of people who aren't focused; that goes for adults as well as kids. If you can't put your full attention into what you are trying to do with that knife, you should put it away and come back to your project when you can. This is especially important for younger, more recently introduced students of "the way of the knife."

There are a few knife safety standards that you must always follow to keep yourself and those around you safe. I have used this set of rules to train hundreds of young people to use knives safely and effectively, and I can't emphasize how important it is.

- WHAT KIND OF KNIFE? Pick a knife that has a fixed blade with a sheath or a folding one that locks open. Don't use a folding knife if it doesn't have a blade lock. Also, make sure it is sharp. Dull knives force kids to push too hard, which often leads to loss of control. It sounds weird, but a dull knife is a dangerous knife.

- CHECK THE SCENE. Is it a good time to use a sharp thing? Is there anyone nearby? If the people around you don't know that you are using your knife because they are playing games and goofing around nearby, then put it away.

- BE AWARE OF YOUR SAFETY CIRCLE. If anyone is within reach of you when you want to use your knife, you are too close to others and should find an area where you have more space. If someone looks like they are about to enter your safety circle, it is your responsibility to sheath/fold the knife and ask them to give you more space because you don't want to accidentally hurt them.

- HAVE A SEAT. Find a nice place to sit down before you open your knife and begin carving. If you are walking around while carving, you are much more likely to cut yourself.

- DON'T CARVE TOWARD YOUR BODY. Every time that I have accidentally cut myself with a knife it was because I broke this rule one way or another. Take a moment to see the path of the blade (where it will travel from point A to point B as you work). Then ask yourself, "Is there any part of my body on that path?" This might sound silly, but if your body parts are in the blade's path, it is just a matter of time before you get cut. As you develop more confidence and control, you may choose to use specific carving techniques that violate this rule, but it comes with a risk.

- PUT YOUR KNIFE AWAY WHEN YOU ARE NOT USING IT. If your knife is a folding knife, fold it up and put it in your pocket. If you have a fixed blade knife, sheathe it. When a knife is left on the floor or ground it can be stepped on, kicked, sat on, broken, dulled, or lost. In general, a knife's live edge should never touch the ground.

The most important knife technique is something you can practice with each carving stroke: the slice. Slicing is when the blade moves across the wood in two planes at once. As the blade pushes forward, it also moves out to the side, along the cutting edge, from base to tip. Make sure that every bit of the cutting edge is in contact with the wood, with each stroke ending so that the very tip of the blade is the last part of the knife that touches the wood as you push the blade forward. With practice this motion becomes natural. The slicing technique gives you more control with less effort, which is one of the ultimate safety skills when it comes to knife use.

For fine detail whittling, you can use your thumbs on the back of the blade (the dull side). Instead of doing the "pushing" motion with the hand and arm that is holding the knife, the thumb from the hand holding the wood pushes the blade forward. This gives you a lot of control and is actually a lot safer, because the "path of the blade" is so much shorter when you use this technique.

The knife is an endlessly useful tool and the skills for using it safely and effectively are priceless.

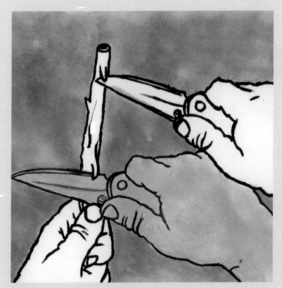

The slice technique: the base of the blade bites into the wood at the beginning of the stroke. At the end, the last part of the blade to touch the wood is the very tip.

CHEWED STICK PAINTBRUSH

CHALLENGE LEVEL

MATERIALS

• Fresh twig

TOOLS

• Pruners
• Pocket knife

Some of my favorite "handmade" paintbrushes are actually made by my teeth! These chewed paintbrushes are made from the twigs of trees with fibrous, and sometimes even tasty, wood. This kind of paintbrush is perhaps one of the oldest designs used by people way back in the day, and they work great today! There are some important details to keep in mind if you want to make a good paintbrush.

TIP: Start out with skinny little twigs. With practice, you can make bigger paintbrushes.

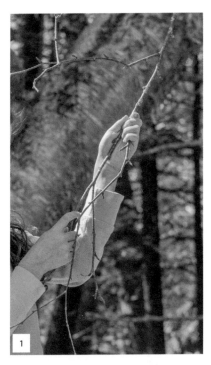

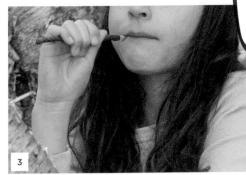

Look for fresh twigs with stringy and fibrous wood and make sure they aren't toxic or poisonous!

1: FIND SOME FRESH TWIGS

I'm fond of sweet birch (*Betula lenta*) and yellow birch (*Betula alleghaniensis*) for chewed twig paintbrushes because of their great root beer taste, but also because of the long wood fibers that make perfect paintbrush bristles when carefully chewed. If you can't find any birch twigs, look for beech, elm, hickory, oak, or maple. These all live in northeast North America, my habitat, and they all have the key traits of being fibrous woods. Get to know which trees in your region make stringy wood fibers and use twigs from them.

Use pruners to snip a twig about the length of a pencil and don't forget to thank the tree that gave it to you!

2: TAKE OFF SOME BARK

Use your knife to make a slice all the way around the twig about 1 inch (2.5 cm) from one end. This is called a "stop cut." Hold the knife at a shallow angle and shave the bark off all around, from the stop cut to the end. With practice you will be able to take the bark off a stick without even cutting into the wood underneath.

3: CHEW

The wood fibers are brittle at first, so instead of chewing, think of this as gently squeezing with your teeth. Put the twig in your mouth and let it soften up for a minute before you start to squeeze. Be gentle at first and don't try to chew all the way through the twig while it is still solid. Loosen up the wood fibers on the outside first. Then slowly break it up the center a little bit at a time. As it breaks apart, focus your teeth on each solid piece, carefully and patiently. Before you know it, the whole end of the stick will be a loose bundle of wood fibers.

PROJECT ፥ 7 ፥ SNAKE PLANT PAINTBRUSH

CHALLENGE LEVEL

MATERIALS

- Snake plant leaf, at least 5 inches (12.5 cm) long

TOOLS

Pruners
Cutting board
Pocketknife
Scissors

This plant is perfect for making paintbrushes! Snake plant (*Sansevieria* species) is a native of tropical West Africa, but is found all over the world as a common houseplant. It has many wonderful qualities, including its strong fibers, found inside its long leaves. We can make a great paintbrush using the leaf as the handle and the fibers as bristles.

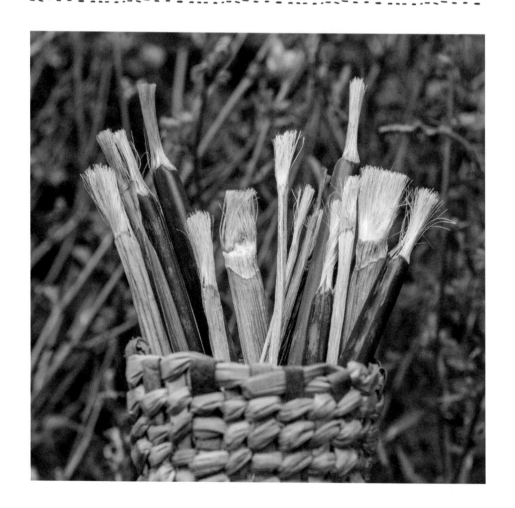

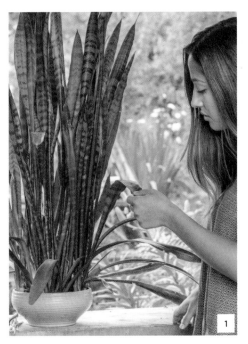

If you don't live in the subtropics, the best place to find snake plant is in a pot living inside someone's house or office.

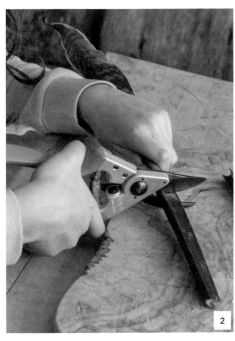

Harvest a whole leaf, making the cut at soil level.

1: FIND A SNAKE PLANT

If you live in the tropics, you can find snake plant living happily outside, sometimes as tall as an average adult human. If you live somewhere colder, the most likely place to find snake plant is in a pot somewhere inside. It is a common plant in public places, like shopping malls, because it is a champ at cleaning the air and it can live for months without being watered.

2: HARVEST A WHOLE LEAF, MAKING THE CUT AT SOIL LEVEL

Use pruners to cut a leaf at ground (soil) level. This will give you enough material to work with for making several paintbrushes. Don't worry, the snake plant will send up a new leaf where the old one was. Cut a section from the base that is 5 to 6 inches (12.5 to 15 cm) long. That will be the first paintbrush.

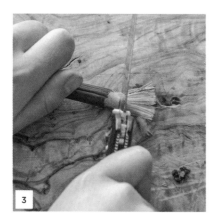

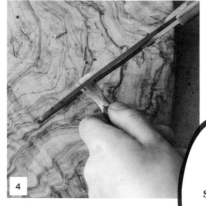

3: SCRAPE OFF THE PULP

The fibers for the paintbrush bristles are on the inside of the leaf stalk. To get to them you'll need to remove the green, waxy outer layer. Put the leaf stalk on a cutting board and use the back of your pocketknife (not the sharp side) to scrape the stalk about 1 inch (2.5 cm) from the end. As the green stuff comes off with the pulp you will see the silvery blond fibers inside. Turn the stalk over and scrape from all sides to get the rest of the pulpy stuff off.

4: TRIM THE BRISTLES

You can shape your paintbrush bristles the way you want by giving them a haircut with a sharp pair of scissors. Cut them straight across, at an angle for a wedge tip, or make a custom rounded tip. Each one will paint slightly differently.

TIP: Plant your leftover snake plant leaf sections in potting soil and with some water and time, they will grow roots!

TIP: Scrape with the knife blade up and angled away from your body so you don't accidentally cut yourself.

Playing Around: Make a Set of Brushes

You can make snake plant paintbrushes in all shapes and sizes! Split thick sections of the leaf into thinner ones to make finer/smaller paintbrushes.

Take some time to look closely at the cool patterns that snake plants have in their leaves. Pick any colors you want and use your new paintbrushes to paint the unique patterns onto a piece of paper. It's okay if they don't look exactly the same. Zoom in with your eyes and focus on a small section of pattern, but paint it big on your paper. The idea is to have fun painting all the cool shapes and designs in your own way.

STICK PALETTE KNIFE

CHALLENGE LEVEL

MATERIALS

• Stick

TOOLS

• Pruners
• Pocketknife

Sometimes a paintbrush doesn't have bristles at all. A lot of painters use flat, flexible painting tools called palette knives. These are great for picking up thick paint and pressing it onto the object or person being painted. Perhaps the oldest known example of a palette knife used for painting was found in Blombos Cave in South Africa. This artifact is made of a flat bone, about 2 inches (5 cm) long, and is 100,000 years old! It's not a big surprise to find out that small flat things were some of the first versions of painting technology. They are easy to make, you can make a set of them from one small branch, and they work great!

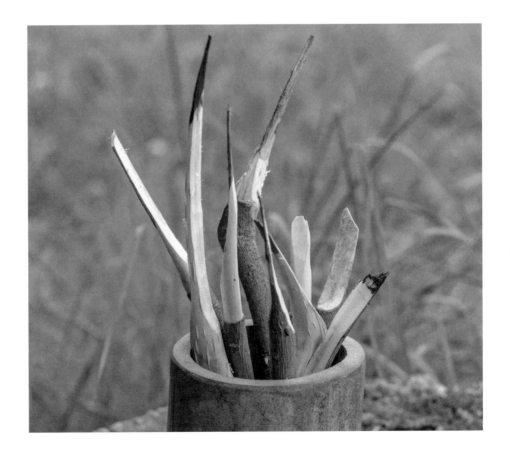

Almost any stick can be whittled into a palette knife.

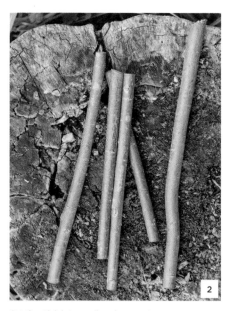

Cut the stick into smaller pieces and remove any branches.

1: FIND A STICK

The stick should be about as big around as your thumb, and at least two or three times longer (6 inches [15 cm] is good). Almost any stick will work. Use pruners to snip a short section from a freshly fallen branch or cut one from a tree that needs pruning. Just make sure it's not poisonous, rotten, or super easy to break.

2: PROCESS THE STICK

If the stick has any branches, snip them off with pruners, so it's a single wand. Save the snipped branches to make more paint palette knives for your collection of painting tools. Next, cut the stick into sections about 6 inches (15 cm) long. Even the smallest tip of the twig at the end of the branch can make an awesome painting tool!

3: CARVE THE STICK

Pick one end of the stick and use your pocketknife to carve a flat spot about 3 or 4 inches (7.5 or 10 cm) long. Use shallow slices to take off super-thin shavings of wood as you carve. When you get close to the center of the stick, turn it over. Now carve that rounded side to be flat like the other side. Try to make the stick look kind of like a butter knife, except with a slightly thicker blade. Keep carving off thin slices of wood until the wooden blade can flex evenly without creasing (folding).

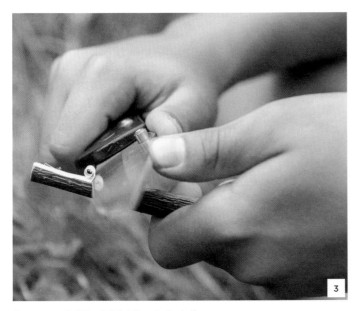

Carve one end of the stick flat like a butter knife.

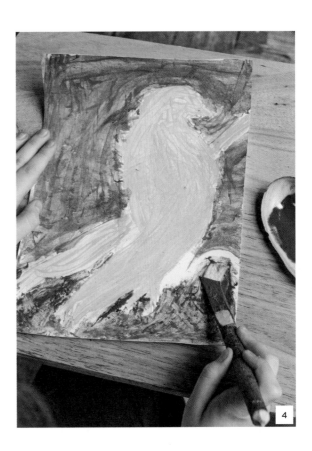

4: SHAPE THE EDGE

Shape the tip with a diagonal line edge. This will give it two corners: one with a sharp (acute) angle and one with a dull (obtuse) angle.

Playing Around: Experiment with Your Palette Knife

Make a bunch of these paint palette knives! You will have fun practicing your whittling skills, and you'll end up with a lot of great painting tools to explore and experiment with.

Try your new palette knife out with some of your home-made paint! Make a batch of paint that is slightly thicker (or pastier) than you might normally make it. Try it out on paper, on skin, on wood, or on any other surface you want to work with.

Experiment with different ways to hold your new palette knives when you paint. All artists develop their own style and techniques. With just a little bit of practice, you will find a lot of cool ways to make unique "brushstrokes."

HAIR AND FUR PAINTBRUSH

CHALLENGE LEVEL

MATERIALS

- Hair or fur (human, horse, dog, goat, deer, etc.)
- Hollow stick
- Waterproof wood glue

TOOLS

- Pruners
- Scissors

Tufts of hair or fur make nice bristles for paintbrushes. Each type of hair and fur is unique, so the paintbrushes you can make with them will each have its own personality, whether you are using your hair or a horse's. Depending on where you live, and what kind of lifestyle your family has, hair and fur from animals may not be easy to find. This project works with any fur or hair, but to keep things easy, we will use hair from *Homo sapiens* (that's you!).

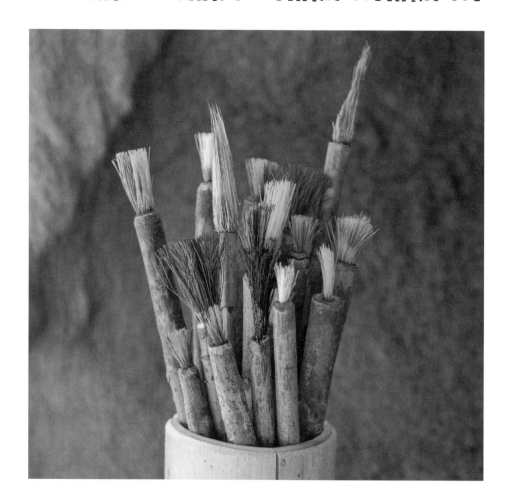

1

If you're in need of a a haircut, save some for this project.

1: GET SOME HAIR

You only need a little bit of hair to make a paintbrush. A lock of hair as big around as a pencil, and 1½ to 2 inches (4 to 5 cm) long is all you need. If you're not ready for a haircut, see if your friends are! They might be willing to give you some of theirs (or maybe fur from their pets). Keep your tuft of hair in a little box or bag until you are ready to turn it into a paint-brush.

TIPS: Horsehair is great. Find out where the nearest horses live and make friends with their humans. Horses get haircuts too, so ask if you can have a little for your project.

If your pet needs a haircut, save some clippings for making paintbrushes!

Playing Around: Getting to Know Your Paintbrushes

Now that you have made a paintbrush with hair, go ahead and make a few more! The first one is the hardest and now that you have some experi-ence, try to make a larger one with more hair and a smaller one with less hair. Experiment with what kind of hair and fur you use, how long you cut the bristles, and how you trim the ends to shape them. The best way to learn how to make better paintbrushes is to paint with them since each paintbrush paints in its own way.

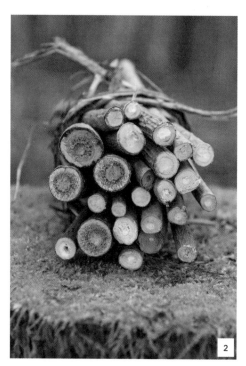

You need a hollow stick or a pithy one like these for the handle.

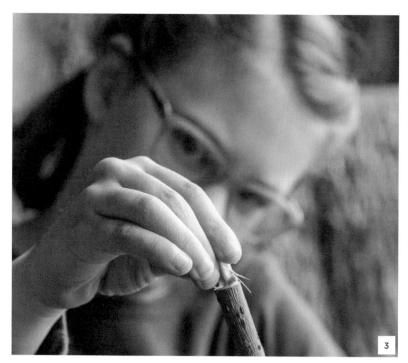

Use a waterproof glue to attach the hairs to the handle.

2: FIND A HOLLOW STICK

Most sticks you find aren't hollow, but bamboo (*Bambusoideae* species) and river cane (*Arundinaria gigantea*) are, so they are great for this. Sticks that have a soft, pithy center can be hollowed out by pushing a smaller twig (or toothpick) into the center. Compress the pith until you have a hole in the end of the stick that is almost as big around as a pencil and at least $1/2$ to $3/4$ inch (1.3 to 2 cm) deep. Some examples of pithy sticks that are a good size are staghorn sumac (*Rhus typhina*), elderberry (*Sambucus nigra*), forsythia (*Forsythia suspensa*), and blackberry (*Rubus* species), to name a few.

Get to know the trees and shrubs in your region to figure out which ones have a soft center that can be hollowed out easily.

3: GLUE THE HAIR INTO THE HANDLE

- Fill the hollow end of the stick with waterproof wood glue and set it upright while you prepare your bundle of hair or fur.
- Use scissors to snip the end of the hair bundle so all the hairs are lined up.
- Hold the bundle as close to this trimmed end as you can between your thumb, index finger, and middle finger, and try to keep it in

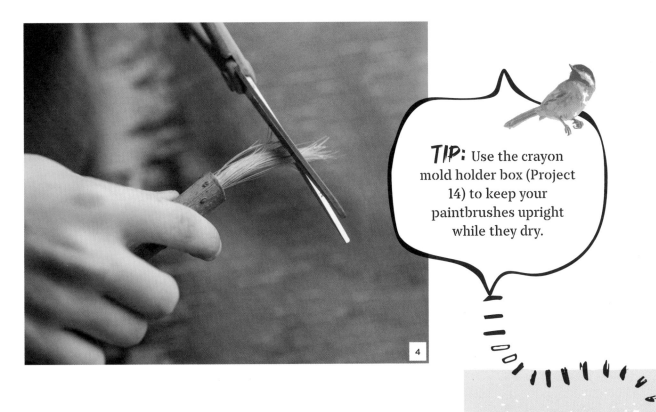

TIP: Use the crayon mold holder box (Project 14) to keep your paintbrushes upright while they dry.

a neat bundle. This can be tricky for young hands.

- Now put the trimmed ends into the hole in the end of the stick and twist the bundle in like a screw.
- Once you get most of the hair in, keep holding it firm while twisting the handle to try to get the hair bundle in at least $3/4$ inch (2 cm) deep.
- Next add a little more wood glue to the base of the hair bundle where it touches the wood handle. Set it upright to dry for at least 2 hours (longer is better) before you use it.

4: TRIM THE BRISTLES

The bristle bundles of paintbrushes can be made in all sorts of shapes. Use a sharp pair of scissors to make it how you want it. Don't cut it too short to begin with. Start by trimming the bristles to about $3/4$ inch (2 cm) long. If you want the bristles to be shorter, you can always snip them again later.

Taking Care of Your Paintbrushes

Paintbrushes are delicate tools that can last a long time if you take care of them. Here are some things to keep in mind:

- Always clean them when you are finished painting. At the very least, use running water to wash the paint out of the bristles. It's best to use soap.

- Don't leave them sitting in water or wet paint for too long.

- Store them in a safe, dry place.

CHARCOAL

Charcoal is the black stuff that is made from organic materials (like wood) when they are cooked without oxygen. Charcoal may be the oldest artist pigment. People have probably used it to draw with for as long as we have used fire. They go hand in hand.

I have seen countless children pick up a piece of charcoal from the edges of the firepit and draw with it on nearby stones and trees. It seems like one of the most natural things a person can do. So it is no surprise that charcoal was one of the black pigments of choice used by my Cro-Magnon ancestors during the last Ice Age. The walls of Chauvet Cave in France are a great example. Those drawings were made over a long period of time, the oldest ones dating back to 32,000 years ago! That's older than Stonehenge and the Great Pyramids by about 27,000 years!

CAMPFIRE CHARCOAL

This first project in this chapter is a scavenger hunt for charcoal. Go to a place where people make campfires, perhaps in your own backyard, or in a campground. Look for the remains of the charred firewood on the edges of the firepit. Collect some of these and experiment with how they work as drawing sticks. Think of them as caveman pencils. It is charcoal in this form that your ancient ancestors first explored for its artistic potential. Bring some home and play around with it in your drawing adventures!

Playing Around: Drawing with Charcoal

Do a complete drawing using only charcoal that you scavenge from old fires.

This is what the first artist charcoal looked like.

THE CHARCOAL KILN CAN

When you burn wood in the open air, most of what's left over when the fire goes out is ash. But when you burn wood in a charcoal kiln, you get mostly charcoal.

A charcoal kiln can is like a small oven box that you put directly in the fire. It's a simple tool that makes it easy to make your own artist charcoal. A nerdy technical name for it is a "deconstructive still." In the old days, people would build elaborate woodpiles buried in a layer of clay and dirt and then build a big fire on top of that.

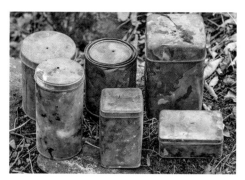

You can make charcoal kilns out of a variety of metal cans with lids.

CHALLENGE LEVEL

MATERIALS
- Metal container with lid (new paint can, tea tin, candy tin, etc.)

TOOLS
- Hammer
- Nail

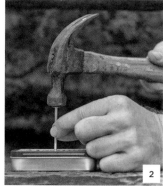

1: GET A CAN WITH A LID

Find a metal container that has a tight-fitting lid. Keep an eye out for candy tins, tea tins, cookie tins, or cracker tins at your recycling center or grocery store (maybe you need some cookies?). You can buy a small, unused paint can from the paint store too. These are free of paint and come with a nice tight lid. I have used cast-iron Dutch ovens too.

2: MAKE THE GAS HOLE

Use a hammer and a nail to punch a hole in the lid of the can or tin. That will be the gas hole. (Younger kids might need an adult's help with this.)

When wood heats up and starts to transform into charcoal, it releases gases. These gases need a way to escape the kiln can or else they build up pressure and blow the lid off! When that happens, air (oxygen) gets in and the wood turns into ashes instead of charcoal. Whoops.

Now you can make some charcoal (see Project 12)!

ARTIST CHARCOAL STICK

CHALLENGE LEVEL

MATERIALS

- Willow sticks (grape vine and various pine species are great too)

TOOLS

- Pruners
- Pocketknife
- Charcoal kiln can (see Project 11)
- Fire
- Fire gloves (optional)

A good-quality artist charcoal stick is capable of creating any shade of the gray scale all the way to a deep and delicious black. Although some of the oldest art in the world is made with it, charcoal is also a delicate medium, because it can smudge easily. While smudging can destroy an unprotected work of art, this trait can also be taken advantage of by creative hands and minds. Drum roll, please . . .

Willow sticks in various stages of the charcoal process.

A charcoal drawing develops. *Fall*, Nick Neddo, drawing with charcoal made from willow.

Woods with a soft density are great for making artist charcoal. Willow and wild grape vine are excellent.

1: GATHER THE RAW MATERIALS

Artist charcoal is only as good as the wood that you make it with. The top three woods are willows, pines, and grape vines. Artists have been choosing these woods for making charcoal for a long time (the 32,000-year-old charcoal drawings in France's Chauvet Cave were made using Scotch pine).

Use field guides and other resources to learn how to identify willows, pines, and grape vines. You can find them living in a lot of different environments if you know where to look on the landscape. Use pruners to harvest a twig here and there, and collect only as much as you need for your project.

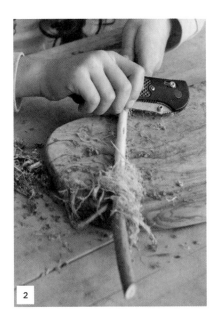

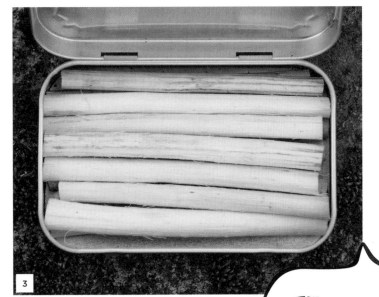

Trim the debarked sticks all the same length and squeeze as many as you can into the kiln can.

2: SCRAPE OFF THE BARK

To make good artist charcoal, you have to take the bark off the sticks first. Use the back of your knife to scrape off the bark, revealing the light color of the wood underneath. This works best on fresh twigs, rather than old dried-out sticks.

TIP: Save the willow bark! We can make ink with it in Project 18.

3: CUT STICKS TO LENGTH AND PACK THE KILN

The goal is to pack as many sticks into the kiln can as possible and still be able to get the lid on tightly. Figure out what your maximum length is for your container and snip a debarked stick to that length. Now use that stick as a pattern to cut all your other sticks the same. Pack them into the kiln can until you can't fit any more. Then put the lid on tight.

TIP: If the lid feels loose or flimsy, tie it down with wire to keep it from opening up while firing.

4: BUILD A FIRE STRUCTURE

See sidebar on page 56.

5: PLACE THE CHARCOAL KILN CAN INSIDE THE STRUCTURE

Build the kiln can into the fire structure, as if it were a piece of firewood. Add the wrist-size logs around it so that it is completely surrounded by wood.

The Tipi Fire Structure

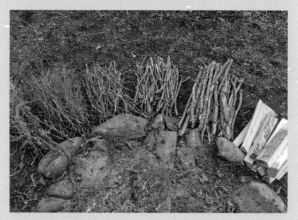

Organize each size of firewood into piles that you can easily reach from the firepit.

Learning to make friends with fire is important on many levels, way beyond making artist charcoal. I believe that responsible fire-building skills should be taught in kindergarten and practiced and improved on throughout life. The role of fire in our lives shows up in many forms in the modern world, and our dependence on it is enormous. Yet how many people can approach the landscape with confidence (and without chemical fire starters to lean on) when challenged with the task of making a fire?

There are many ways to build a fire structure, but one method in particular is the most reliable in the widest variety of weather conditions: the tipi fire. For this reason, I recommend that you practice this way of making a fire before any other options.

A. PICK A GOOD SPOT TO HAVE A FIRE.
Make sure that your region isn't in a fire restriction status before you make a fire. If there is a fire ban in your area, it is important to respect it. In that case, wait until the fire ban is lifted or go somewhere where it is safe.

Build a platform of stones as a firebase. This insulates the ground from the most intense heat and keeps things cool. Or, use a container like a grill, fire pan, woodstove, or fireplace.

Is water nearby if you need it? Do you have some with you?

B. GATHER FUEL. Think of the fire as a living creature and the firewood as its food. To be good fire food, the wood has to be dead and dry. Pick it up off the ground if you are in a wet climate.

Learn how to tell whether a tree is dead or alive in all seasons. If you bend a twig and it doesn't snap, leave it alone.

The fire structure is built with layers of wood, from smallest on the inside to largest on the outside. Each layer of wood is slightly fatter (in diameter) and longer than the previous layer.

- **TINDER:** This is the finest, and most flammable, of all the fire food. It is the first of all the layers of fuel that gets ignited.

- **TWIGLETS:** The most important size of fire food is the smallest because the fire needs these to start. These are the skinny twigs or "twiglets." Look for tiny twigs like a mouse's tail or the "lead" (actually graphite) of a pencil. When these twiglets light they create a hot fire that burns out quickly without the next size of firewood in place: the "pencil twigs."

- **PENCIL TWIGS:** These sticks are about the size of a pencil in diameter but not as big around as your thumb.

- **MARKER STICKS:** The next size of firewood to collect is wood with a diameter of fat markers, but at least twice as long.

- **WRIST STICKS:** Next you want to find pieces of wood that are the diameter of your wrist and about as long as your forearm from wrist to elbow.

C. BUILD THE LAYERS. This fire structure has a "doorway" built in. This gives you a place to put the tinder that you need to actually start the fire and it lets the fire breathe so it can burn hot, with less smoke.

- Grab all of the twiglets in your hands and separate them into two bundles, one in each hand.

- Now place one end of each bundle in the center of your firepit 5 to 6 inches (12.5 to 15 cm) apart from one another and then bring the top ends of the bundles together so they are touching. This makes a triangular shape.

- Turn this into a cone shape as you wrap the twigs around in a circular footprint, making it hollow on the inside with a "door" open in the front.

- Next, use all of the sticks from your "pencil twigs" pile and place them evenly around the base, making sure to leave the doorway open in the front. At this point the structure should

be 10 to 14 inches (20 to 30 cm) tall and about the same width at the base.

- Now add the "marker" sticks in the same way, placing them evenly around and leaving the door open.

- Repeat this process with each size of firewood, from small to large. With each layer the structure gets wider and taller.

Never leave a fire unattended and make sure it is completely out before you leave the area. Pour water on it until there is no more smoke.

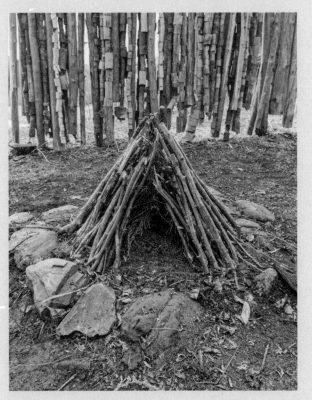

The finished fire structure, ready to be lit.

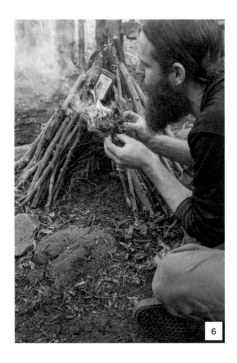

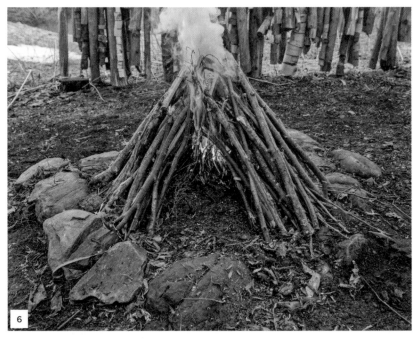

Hang out with the fire and enjoy its company while your charcoal is firing.

6: LIGHT THE FIRE

Catch the tinder with a flame to light the fire. There are many flame options, from friction fire to matches or a lighter. As the fire burns down, add new wood around the kiln can, wearing fire gloves if possible.

When the kiln can starts cooking, you will see a flame come out of the gas hole. These are the natural wood gases burning as they leave the can. When the gas hole flame disappears, the wood has finished its transformation into charcoal.

7: OPEN THE KILN CAN!

It's best to wait until the fire is completely out before you open the kiln can to find your treasure inside. But if you can't wait, use sticks as tongs or fire gloves to take it out of the heat. If the lid comes off too soon, hot charcoal sticks can ignite with the sudden exposure to oxygen, making ashes instead of charcoal. Let the kiln can cool off completely before you open it.

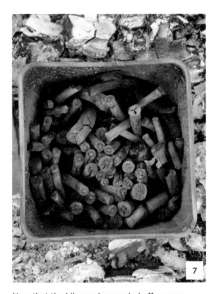

Now that the kiln can has cooled off you can open it up and start drawing with your new charcoal artist sticks!

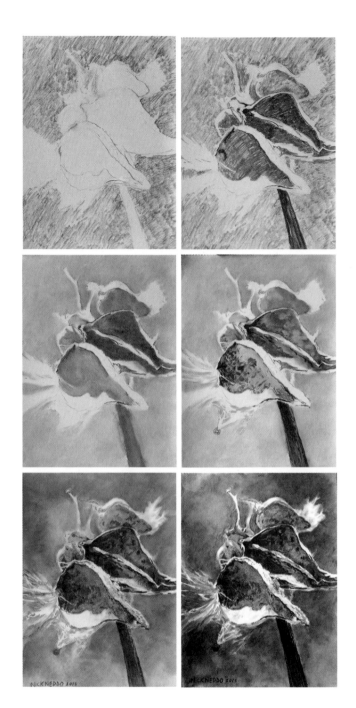

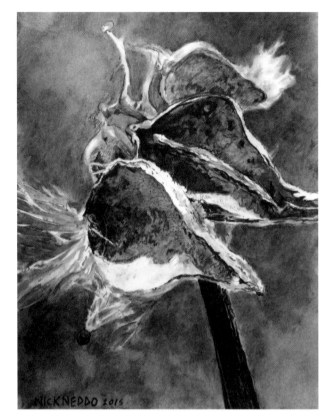

Milkweed Pods, Nick Neddo, drawing with charcoal made from pine.

Playing Around

There is so much you can do with your new charcoal sticks!

- Make rubbings with them (Project 27).
- Stencil with them (Projects 30 and 32).
- Make paint with them (Projects 1, 2, 3, and 4).
- Make ink with them (Project 17).
- Make crayons with them (Projects 14 and 15).
- Draw with them.

Make a gray scale with charcoal. When you start experimenting with your new artist charcoal, see how many different shades of gray you can draw. What is the lightest shade you can make? What is the darkest?

PROJECT ⋗ 13 ⋖ CHARCOAL HOLDERS

Charcoal holders add a handle to your artist charcoal, which is kind of a game changer. They are nice when you want to hold your artist charcoal stick like a paintbrush or pencil. Charcoal can be messy, and sometimes that's part of the fun. But it's nice to have the option to keep your fingers clean. This is when a charcoal holder comes in handy. And the extra length that you get with one helps keep your hand from accidentally smudging across your drawing. They are fun projects, and they're pretty easy to make.

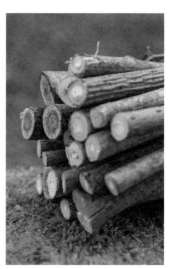

You can see the pithy center of these sticks.

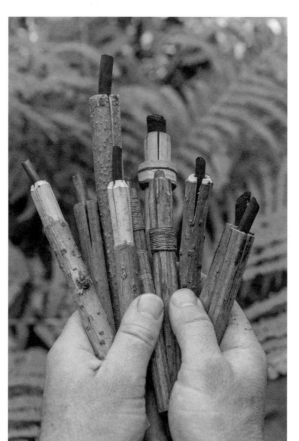

Charcoal holders can be made out of nearly any hollow or pithy sticks.

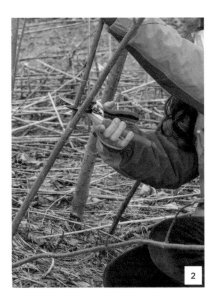

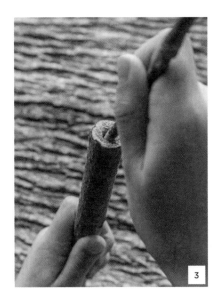

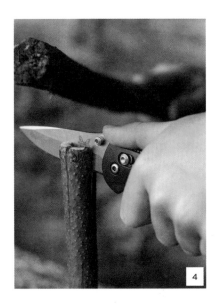

1: FIND STICKS

Get to know shrub and tree species that grow hollow or pithy (foamy or corky in texture) sticks. They are both great for making charcoal holders. Good options include bamboo, elderberry, staghorn sumac, blackberry cane, and honeysuckle.

2: CUT THE STICKS

Use pruners to cut your stick to the length of a pencil or paint-brush. If you are using bamboo, make one cut 2 inches (5 cm) from a branch node, leaving the node as part of your holder.

3: CLEAN OUT THE CENTER OF THE STICK

Using an awl or hardwood stick, compress the pithy core toward the stick center to make room for the charcoal stick.

4: MAKE THE TINES

The tines are the part of the charcoal holder that do the actual holding. They are slightly flexible so they can squeeze your artist charcoal tightly into the holder.

Parents/adults, make sure you are around to offer a hand for this one.

- Stand the stick upright on a table or other flat surface.
- Center your knife blade at the top of the stick so that there are two half circles when you look down at it.
- Now let go of the stick, but keep it upright, holding it with your knife blade.
- With your free hand, use a light mallet (or stick) and tap the back of the blade until a shallow split forms. Be careful not to make this split more than 1 inch

(2.5 cm) deep or your holder may end up in two pieces!
- Make another split across the first one, forming an "X."

5: LOAD IN THE CHARCOAL

Choose charcoal sticks that are the same size or slightly bigger than the opening of your charcoal holder and about 2 to 3 inches (5 to 7.5 cm) long. Put one end into the charcoal holder until it's nestled in tight. If it is loose, find one that is a bit fatter. Now you're ready to draw!

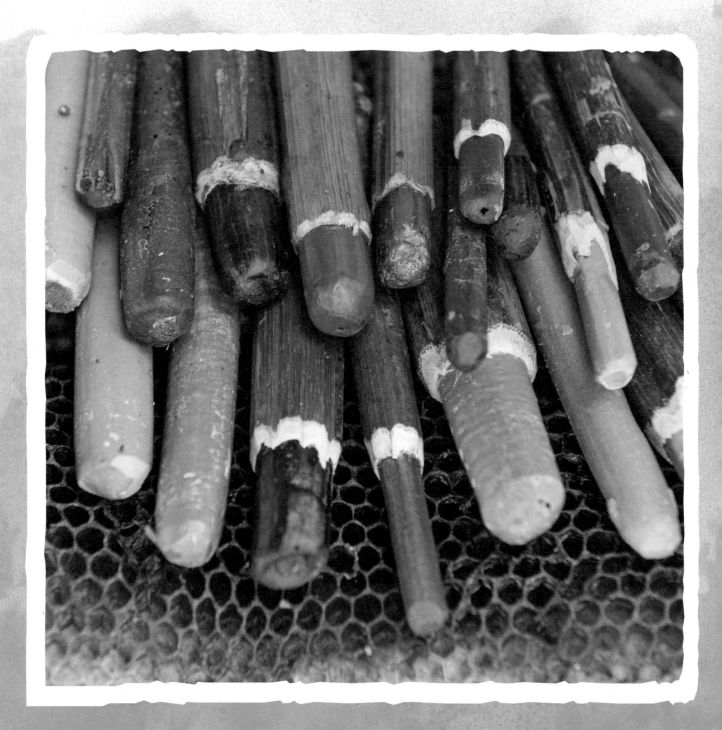

CRAYONS

A crayon is a stick of pigmented wax. Technically, it also refers to charcoal, chalk, or other materials used to draw. There are different kinds of crayons, each variety made with a different kind of binder. When wax is used as the binder it is technically a "wax pastel," but most of us just call those crayons.

Crayola did not invent crayons; they just made a lot of them. The ancient Egyptians used hot beeswax mixed with pigment to color stone. It seems likely that they also made their own version of "wax pastels," but we don't know for sure. In 1600s Europe, artists made pigmented sticks with oil as the binder. This made a good drawing tool, but they were weak and messy. Eventually, wax replaced oil as the binder of choice. This made them stronger and easier to handle; the modern crayon was born.

One of the great things about crayons is that they are an all-in-one drawing tool. No need to bring ink, paint, or water. You don't need any special tools or materials, just a crayon and a surface to decorate.

CHALLENGE LEVEL

MATERIALS

- Stone pigments (see Project 2)
- Knotweed or bamboo for crayon molds
- Beeswax

TOOLS

- Pocketknife
- Cardboard box
- Tape and wax paper (optional)
- Hot plate
- Extension cord for electricity (optional)
- Cutting board
- Metal cup or dedicated project pot
- Stirring sticks
- Small funnel
- Paper towels

It's a pretty cool process to make your own crayons. It's even cooler when you use natural beeswax and make your own pigments and crayon molds from the landscape! The process of refining pigments from stones is covered in detail in Project 2. The prerequisite for making crayons with rocks is to make a very fine pigment of whichever stones you are working with.

To do this project you need to learn about making pigments first. No problem! Go to Projects 1, 2, 3, or 4. Come back to this project after you work through the ones in that chapter.

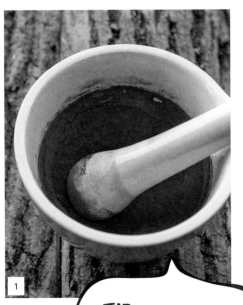

TIP: Use pigments that are ground extra fine and processed thoroughly.

1: PROCESS THE PIGMENTS

Use the water-refining trick (see Project 2) to get the pigments as fine as possible.

You want to use tiny pigment particles that aren't too heavy and chunky. They need to stay suspended in the hot wax as long as possible. If the pigment is too rough and heavy, it will sink to the bottom of the crayon mold and make a low-quality crayon.

Let the pigments dry out completely before mixing them with the wax.

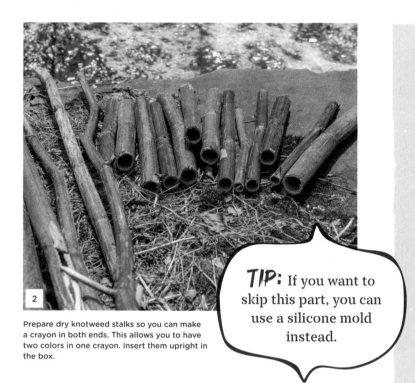

2

Prepare dry knotweed stalks so you can make a crayon in both ends. This allows you to have two colors in one crayon. Insert them upright in the box.

TIP: If you want to skip this part, you can use a silicone mold instead.

2: HARVEST AND PREPARE THE KNOTWEED (OR BAMBOO) MOLDS

- First, read the sidebar about knotweed to understand how to harvest it without spreading it.
- Pick brown, dry stalks that are big enough for a kid's thumb to fit inside. If they are much smaller they will be hard to fill up with the colored wax and they will make weak crayons.
- Use a sharp, fine-toothed saw or pocketknife to cut the knotweed stalks so that there is a node in the center of a 6- to 10-inch (15 to 25 cm) length tube, with both ends open.

The nodes will be the bottom of the crayon mold, making a tall skinny cup. Each mold is double sided, sharing a single node, and can make two crayons. When the first batch has hardened, turn them upside down and another set of molds will be ready to go!

Harvesting Knotweed without Spreading It

Japanese Knotweed is native to East Asia but has established itself as an aggressively invasive species in several countries because of careless handling and ignorance. It can grow new plants from small pieces of stem nodes and roots. It is listed by the World Conservation Union as one of the world's most invasive species, which is an impressive distinction that deserves our attention.

The important thing when collecting and handling knotweed is to avoid spreading its living parts in new places! Collect stalks in the fall after they have dried up and turned brown for the season. Look for stalks that are brown, but still fresh enough to not have cracks, which will just leak out the precious pigmented wax. You can also harvest green stalks and let them dry indoors, where they can't escape and start a new colony.

Process the knotweed stalks on site where you harvest them. This ensures that if any discarded pieces of plant material grow into new plants, they will already be in an area that has been colonized by knotweed.

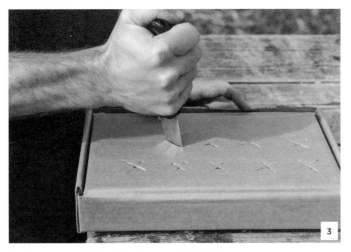

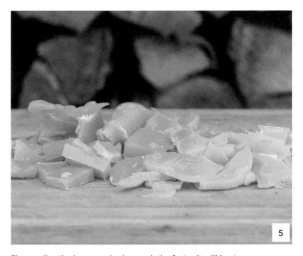

One easy way to make the holes in your mold holder box is to make an X with your knife.

The smaller the beeswax is chopped, the faster it will heat up and liquefy. Keep the heat low and stir often.

TIP: Tape some wax paper to the bottom of the box before you poke the holes in it for the crayon molds. This will make it easier to salvage the overflowing beeswax. When the wax hardens, peel it from the wax paper and reuse it.

3: MAKE A MOLD HOLDER

Now you will need to create a mold holder out of something like a cardboard box. Turn a box upside down and use a sharp stick or knife to poke holes at regular intervals in the bottom of the box. Insert your crayon molds into these holes, and make sure they are standing upright.

4: SET UP YOUR WORK-SHOP SPACE

Make crayons outside in case the wax gets too hot, which can make smoke. Set the hot plate up on a flat surface, like a flat stone, concrete slab, or tabletop. You may need to use an extension cord to plug it in to a power source. Clear away any flammable materials that could cause trouble. Gather your materials together and keep them all within reach.

5: PREPARE THE BEESWAX

Next, use the cutting board and knife to shave, chop, or carve the beeswax into small pieces and then put them in the project pot (or metal cup). Put the pot on the hot plate on the low heat setting. This takes a little while for the wax to liquefy, but we need this to happen slowly to keep the wax from burning. Be patient and use this time to prepare the next steps.

Bees Make Wax from Flowers!

There are thousands of different bee species, and all of them are vitally important to the health of the ecosystem. But it is only the honeybees (of the genus *Apis*) that make beeswax.

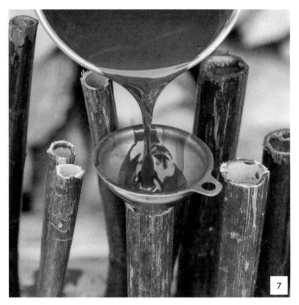

Use a little funnel to pour the colored wax into the molds.

TIP: Wipe out the metal cup and funnel with a paper towel immediately after you are finished with each color batch of crayons. It is much easier to clean off the waxy residue when it is still warm. If you need to heat them up a little first, it is worth it compared to trying to get all the wax out when it is cold and hard.

6: MIX THE PIGMENT WITH THE WAX

When the beeswax is completely liquefied, mix in the pigments. In general, more pigment makes crayons that draw with more color, which we like. But, there is a limit to how much pigment can be added before the crayon loses all of its strength and falls apart in your hands. Keep notes on the ratios that you experiment with so you can adjust them to make your crayons more or less saturated.

The basic recipe to start with is about 1 teaspoon (4 g) of pigment for each 1 table-spoon (15 g) of beeswax. This is a loose ratio, because every pigment is going to act slightly different in beeswax.

Take the wax pot off the heat source and stir it with a stick while you add the pigment, gradually sprinkling it in to avoid clumping. Continue stirring as you add the amount of pigment you want for the number of crayons that you are making.

7: FILL THE MOLDS

Pour the hot, pigmented beeswax into the molds. The wax hardens fairly quickly as it cools, so the working time to fill the molds is just a minute or two. With this step of the process, slow is smooth and smooth is fast, meaning that if you go slow and smooth you will be in control and not make mistakes. This part can be dangerous for younger kids who don't have focus and steady hands.

Set up the little funnel in the first crayon mold. Give the pigmented wax a stir before you pour it into the funnel—slowly—to avoid overfilling and losing a bunch of the colored wax. Repeat this process as you fill each mold, stirring the wax before each pour.

When the crayon molds are full, spend a minute or so tapping on the mold box to help any trapped air bubbles come to the surface before they get stuck in your crayon.

Let the crayons cool and cure for an hour or two before you try them out. Once they have hardened, you can unwrap them from the knotweed molds, or leave them in the molds as a protective skin. They can be sharpened to reveal the drawing end of the crayon as needed.

PROJECT ⋗15⋖ CHARCOAL CRAYONS

CHALLENGE LEVEL

MATERIALS

• Artist charcoal sticks
 (see Project 12)
• Beeswax

TOOLS

• Hot plate
• Extension cord
 (optional)
• Metal cup or project
 pot
• Fork
• Stirring stick

Some of the first crayons were made with crushed charcoal as the black pigment. They are kind of like artist charcoal sticks, but because they have a wax binder added in, they don't smudge. Charcoal crayons draw with deep black lines and are quite nice to work with.

There are two ways that I like to make black crayons with charcoal. One is to go through the same process that is described in Project 14, but with crushed charcoal as your pigment instead of crushed stones. My new favorite way to make charcoal crayons is a technique that I actually came up with while writing this book! We still need beeswax as the binder and charcoal as the pigment. But the process is completely different (and easier). To make this kind of charcoal crayon you have to first work through Projects 10, 11, and 12. Once you have a nice batch of artist charcoal sticks, you can move on to this project.

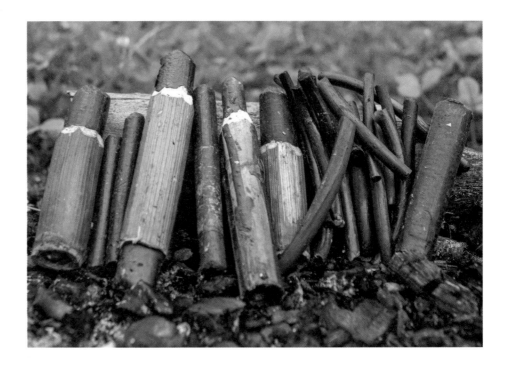

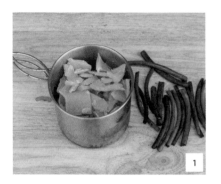

1: PREPARE THE CHARCOAL STICKS

The length of the charcoal sticks has to be adjusted to fit your wax pot and be completely submerged by liquid wax, whether it's a tin can, metal cup, or small project pot.

2: HEAT UP SOME BEESWAX

Set up your hot plate outside (using an extension cord, if necessary) and heat up some beeswax in your wax pot until it is liquefied, stirring occasionally. Keep the hot plate set on low heat so the wax doesn't melt too fast and burn.

3: ADD THE ARTIST CHARCOAL

Put some artist charcoal sticks directly into the wax pot. They will float at first, but then you'll see tiny air bubbles rushing out from the ends. The goal is to replace all the air pockets inside the charcoal with beeswax. Keep them in the hot wax until they stop making air bubbles.

4: LET THEM CURE

When the last of the tiny air bubbles stops coming out of the charcoal sticks they are done with their wax bath. Turn off the hot plate. Take them out of the wax with the fork and set them aside to cool and cure. Congratulations! You just made some very unique charcoal crayons!

Playing Around: Experimenting with Your Crayons

- Hey! Why not use papier-mâché to wrap your new handmade crayons? Check out the techniques in Projects 33 and 34 and get creative!

- Try your handmade crayons out on different surfaces. Aside from paper, they are great for decorating concrete walls.

- Beeswax crayons are great for stenciling and rubbing too!

- Try making crayons in different sizes so you can draw with big fat lines as well as extra fine ones.

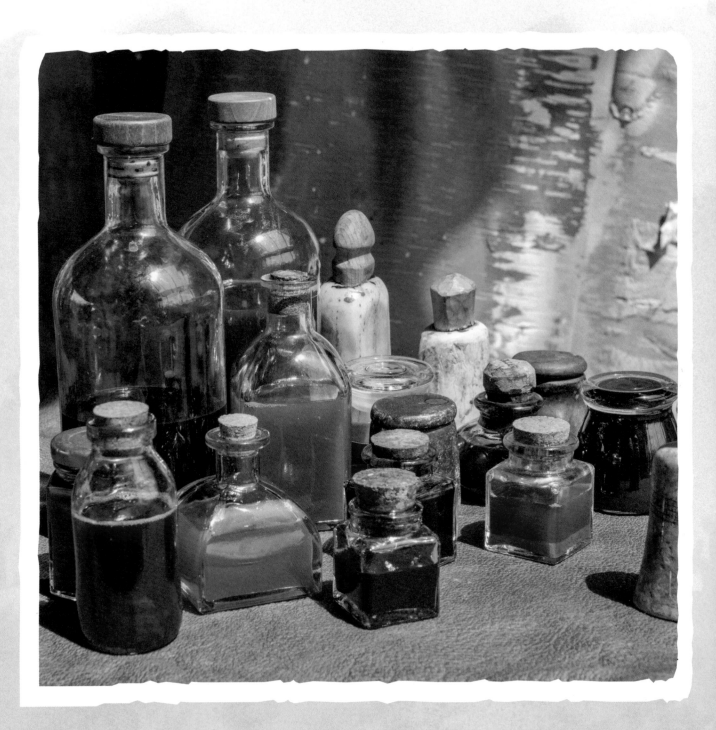

INKS

Ink has been used all over the world throughout history, with each region and culture coming up with their own unique recipes. The ancient Egyptians were making ink at least 4,600 years ago, drawing and writing on the paper of the time, papyrus. In China 4,300 years ago, ink was being made from animals, plants, and minerals and used with fine paintbrushes.

How is ink different from paint? The two main differences are the consistency and how they are used. Ink is typically thinner (more watered down) than paint and paint is more paste-like than water-like. If you dilute paint and use it with a pen to make a drawing it becomes ink. If you let your ink thicken and use a paintbrush to make a painting with it, it becomes paint.

You can make ink from a lot of natural treasures, each with its own features. This chapter explores ink starting from a playful angle and then gets a bit more advanced as we move through the projects.

PROJECT ÷16÷ BERRY INK

CHALLENGE LEVEL

MATERIALS
- Juicy berries
- Paper

TOOLS
- Mortar and pestle
- Bowl
- Bandana or old T-shirt
- Jars

Berries make life better for obvious reasons. One (less obvious) is how easy it is to convince them to share their pigments with you for making ink. Another cool thing about using berries for ink is that you don't have to add a binder because the sugars and pectin in most berries fulfill that role. Some berries are relatively dry and the liquid they do have may not be colored with much pigment in the first place. Other berries have so much juicy pigment that you can use the berry itself as a drawing tool, a self-contained unit that is both pen/paintbrush and ink. Once you have overcome the challenge of not eating them, making ink from berries is fun and easy. Start out with the ones that stain your fingers when you eat them.

TIP: Some pigments hold their color permanently and others fade over time, especially in direct sunlight. Colors that start bright and slowly fade are called "fugitive" (because they run away). Berry inks do this.

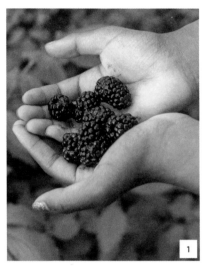
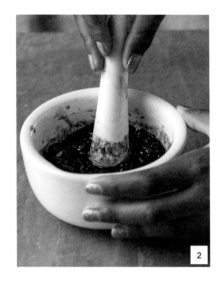
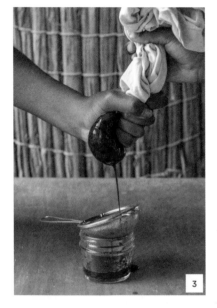

The best way to get berries is to pick them your-self directly from where they grow.

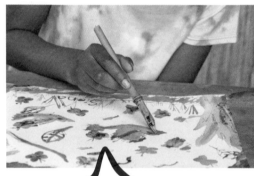

1: GET SOME BERRIES

The berries available will depend on what season it is when you get your hands on this project. Start out with raspberries, blackberries, blue-berries, elderberries, or Con-cord-type grapes. Be sure to pick plump and juicy ones.

2: SMOOSH THE BERRIES

Put a handful of berries in the mortar and pestle. Keep it on the small side, being careful not to overfill it. Crush each berry thoroughly and spend some time focusing on the berry skins, which tend to be where most of the pigments are hiding. Crush and grind them against the bowl of the mortar so they release as much pigment as possible.

3: COLLECT THE JUICE

Line a bowl with a cloth, such as a bandana or an old T-shirt. Dump the first batch of mashed berries and their juice into the bowl, catching all the mash on the cloth. Care-fully make the cloth into a pouch, wrapping the edges around the berry mash. Pick it up and squeeze it until you get every last drop of juice out. When the first batch of crushed berries stops dripping from the cloth, empty it into the compost and repeat the process.

Now you can try out your ink with one of your dip pens (see Projects 20, 21, and 22)!

TIP: If you have berries in the freezer already, take them out to thaw. When they are no longer frozen, a puddle of juice will build up in the container they were frozen in. Pour this out into a jar and use it as ink! Eat the berries or put them back in the freezer.

PROJECT :17: CHARCOAL INK

Before soot became widely used to make high-quality black inks, finely ground charcoal was common. If you are making artist charcoal for drawing (see Project 12), then you already have most of what you need to make a great black ink for drawing and writing.

CHALLENGE LEVEL

MATERIALS

- Charcoal
- Binder of choice (perhaps honey, gelatin, or glue)
- Water

TOOLS

- Stone mortar and pestle
- Canning funnel
- Jars
- Measuring cups and spoons
- Porcelain mortar and pestle

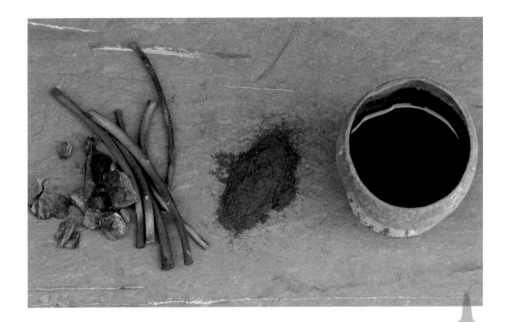

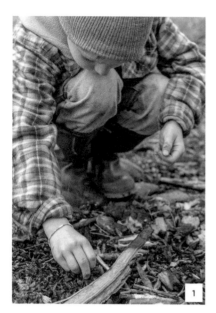

Charcoal can be found at campfires, or made intentionally like in the process of creating charcoal artist sticks (see Project 12).

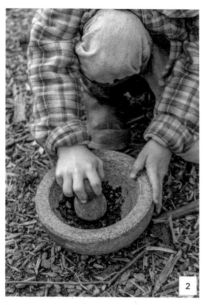

The stone mortar and pestle makes pulverizing charcoal easy.

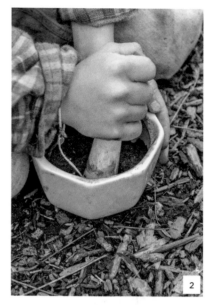

Use a finer textured mortar and pestle to grind the charcoal finer.

1: FIND OR MAKE SOME CHARCOAL

See Projects 10, 11, and 12.

2: DRY GRIND THE CHARCOAL

First, put a few charcoal pieces into the stone mortar (less than a handful) and begin grinding. It is always easier to work with small amounts at a time when grinding by hand. Crush and grind the charcoal until it is as fine as all-purpose flour.

Be patient and persistent: the more thorough and focused you are with this step, the better the ink will be. When the first handful of charcoal is finely powdered, pour it out through a canning funnel into a jar.

Now repeat the process with another small handful of charcoal until you have at least 2 tablespoons (16 g) of very finely powdered charcoal.

TIP: Put a couple drops of rosemary essential oil in your ink when gelatin is used as the binder. This will help extend its shelf life and gives it a pleasant aroma.

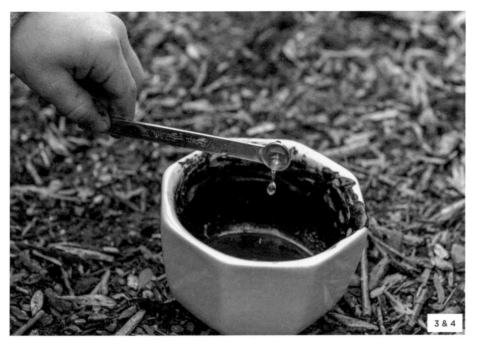

3 & 4

Dissolve ⅛ teaspoon of gelatin granules in 1 cup (240 ml) of water. Grind 1 tablespoon (15 ml) of the gelatin water and 1 tablespoon (8 g) of charcoal powder in the porcelain mortar and pestle.

3: PREPARE THE BINDER

For this project, we will work with gelatin as a binder, although you could use a variety of other sticky things. Gelatin is a form of glue, so it is well suited for ink binders.

Get a box of the unsweetened, undyed gelatin at the grocery store. Stir ⅛ teaspoon of gelatin granules into 1 cup (240 ml) of hot water until they dissolve.

4: WET GRIND THE BINDER AND CHARCOAL

It is time to graduate to a porcelain mortar and pestle to refine the charcoal even more. For this step we will be doing a wet grind.

Put 1 tablespoon (8 g) of charcoal powder in the porcelain mortar. Next, add 1 tablespoon (15 ml) of the gelatin water and grind with downward and outward pressure.

The wet grind does two things: it makes the pigments finer, and it mixes them with the water. You will notice that the charcoal wants to float at first. Be patient and grind the charcoal for at least 10 minutes. The longer you grind, the better it will be.

When the first batch is mixed up, add another tablespoon (8 g) of charcoal powder and another tablespoon (15 ml) of gelatin solution and repeat grinding.

5: BOTTLE YOUR INK

Keep your ink in a jar with a tight lid. A canning jar will do, but try to find a cool little jar with a cork stopper. Use a funnel to pour your ink into the jar and start playing around with it!

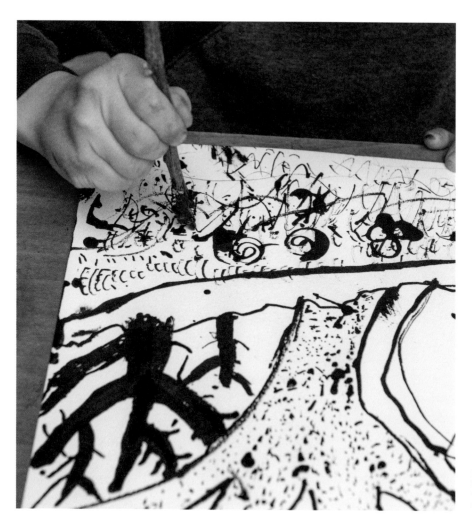

Explore the ink's potential by playing around with it. Once you use it you can decide whether you want to make any adjustments to the ratios of charcoal, binder, and water to suit your needs.

Playing Around: Switching Up the Variables

The way this ink works and feels depends on a few things. One variable is how fine the charcoal pigments are ground. Another variable is how thick or thin the ink is. And yet another factor is how much binder is added. Part of the fun with making your own art supplies from scratch is adjusting these ratios to get an ink that you like. It's all pretty cool when you get right down to it.

Coconut Palm Canopy, painted with ink made from charred coconut shells

PROJECT ⋮18⋮ ACORN INK

CHALLENGE LEVEL

🍂 🍂 🍂

MATERIALS

- Acorns
- Water
- Rusty metal bits
- Apple cider vinegar
- Binder of choice (gum arabic, honey, plain gelatin)

TOOLS

- Stone mortar and pestle
- Slow cooker or metal cook pot
- Fine-mesh strainer or old T-shirt
- Canning funnel
- Pint (480 ml) jars
- Measuring cups

There is a special kind of ink that you can make from natural materials that contain tannic acid. Plants and trees make tannic acid to protect themselves from infection. When a tea of tannic acid is combined with an iron solution it makes a really cool (and safe) chemical reaction. This produces the unique purple-blue-blackish colors that this variety of inks all have in common. It's often referred to as "iron gall" ink, because of its two main ingredients: a solution of iron in vinegar and high amounts of tannins (traditionally found in oak galls). It was in widespread use in Europe for 1,400 years or so as the most common ink used for writing and fine art. In fact, the great Italian Renaissance man Leonardo da Vinci made many of his drawings with iron gall inks. This kind of ink was used in The Book of Kells in Ireland 1,200 years ago. It is a great "permanent" ink because of its ability to bite into the paper where it can't be rubbed off like some other inks.

In the following project, we will get tannic acid from acorns and iron from rusty metal objects to make a rich, bluish-black ink that can be used for any of your creative pen and ink work.

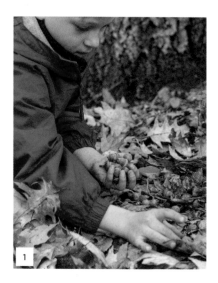

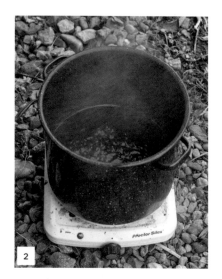

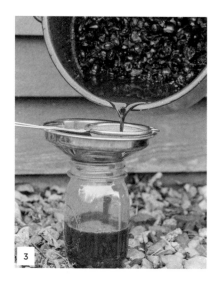

1: COLLECT ACORNS

I love hanging out with oak trees. And who doesn't enjoy a good scavenger hunt? Acorns are loaded with tannins and are free for the taking when we are lucky enough to have a year when the oak trees make a lot of them (a mast year). You don't have to be too picky with the quality of the acorns (like if you were going to process them for food). As long as they are not rotten, tap in to your inner squirrel and grab 'em up. Even the smallest of hands can join in! There is enough tannic acid in those little units that you can make a decent batch of ink even if you can only get enough to fill your pockets.

2: MAKE TEA

Now we have to boil the acorns to get their tannic acid. This happens a lot faster if we crush each one first. Use a stone mortar and pestle (the same one you use for making paint) to smoosh each acorn into bits. Next, put those bits into a slow cooker or a pot on the stove and cover with water. Bring it to a boil and allow it to boil for at least 1 hour. The longer the acorns boil, the more tannic acid is extracted into the "tea." Be sure to keep your eye on the water level so it doesn't dry out and burn (add more water as needed). Adult supervision may be needed here.

3: STRAIN THE TANNIN TEA

When the water has turned a deep brownish red color, and is less than 2 cups (480 ml), it is time to strain it. Take the pot off the heat and let it cool down. Next, pour it through a fine-mesh strainer into a funnel placed in a pint jar. (You can use a bandana or an old T-shirt for this if you need to. In that case, use a rubber band to tie the fabric around the edge of the jar rim so it doesn't move around when you pour the acorn tea through it.)

Willow Bark Ink!

This same recipe can be used to make ink from the bark that you scrape off willow sticks when you make charcoal artist sticks (see Project 12). Willow bark is full of tannic acid, so you can use it instead of acorns. This ink has a pleasant and distinctively "willowy" smell and is a joy to work with.

Start a Rust Farm!

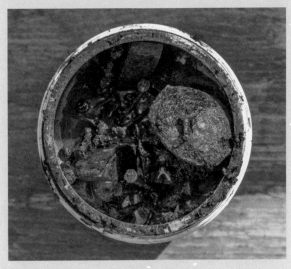

Rust juice is easy to make and comes in handy with some special art projects!

This ink project needs iron in order for the interesting alchemy to take place. Iron is the most abundant element on Earth, so it should be pretty easy to find. We will be using rusty metal bits soaked in vinegar to get what we need for this project.

- Get two containers with lids. They can be mason jars or plastic jugs.

- Next, find rusty metal things like nails, screws, nuts, bolts, railroad spikes, or anything rusty and small enough to fit into your container. If it's easier to find, use steel wool instead. Gather enough to half fill each of your containers.

- Now, pour vinegar into one of the containers, covering the metal bits. I prefer apple cider vinegar because it comes from plants, while white vinegar comes from fossil fuels.

- A healthy rust farm needs oxygen. So, once you cover the metal bits with vinegar, carefully pour the vinegar from one container into the other. After each container of metal gets a vinegar bath, it starts to rust as it air-dries. Swap the vinegar back and forth at least once each day.

It may take a little while before you see anything happening, but in a few days you should have a nice supply of rust juice. You can keep this process going indefinitely. I have a batch of pet rust juice that I have been passively maintaining for several years and I am quite fond of it.

TIP: Set some of the acorn tea aside and add rust juice to the rest. This will give you two different color inks: one a sepia tone, and the other a purple-bluish-black color.

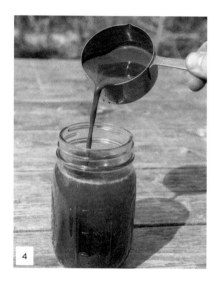
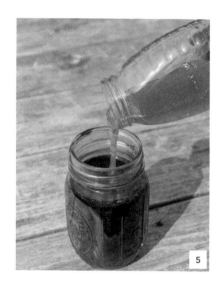

4: ADD SOME RUST JUICE

Stir up the rust juice in its container (see sidebar), and be sure to scrape any obvious rust residue off the metal so it can dissolve into the vinegar. Next, pour about 1/2 cup (120 ml) of it out into the tannic acid tea you made with the acorns. Immediately, you should see the color of the tea begin to change. It takes a few minutes for the color of the liquid to change completely. This is a pretty cool part of this process and is fun to see!

5: ADD A BINDER

This solution will work pretty well as ink in this form, but if we add a binder it will be more satisfying to use. Traditionally gum arabic was used, but if you don't have that on hand you can experiment with some other sticky things. Honey is a good option. Gelatin (unsweetened and not dyed) is a good binder for this ink too. Whatever sticky substance you decide to add as a binder, I recommend using about 1 part binder to 6 to 8 parts iron tannin solution.

Playing Around: Using Your Acorn Ink

- Try this ink out with a paintbrush as a watercolor "paint."

- Try your acorn ink out in a pump sprayer for stenciling; see Projects 30, 31, and 32. It's perfect!

- This kind of ink was traditionally used for writing. Use it with one of your finest pens to write a letter to a friend.

- Try this recipe with black tea instead of acorns!

PROJECT ◦19◦ BLACK WALNUT INK

CHALLENGE LEVEL

MATERIALS
- 1 quart (170 g) black walnut hulls
- Water
- Binder of choice (gum arabic, honey, plain gelatin)
- 1 teaspoon iron/vinegar solution (optional, see Project 18)

TOOLS
- Stone mortar and pestle
- Work gloves (optional)
- Slow cooker
- Fine-mesh strainer
- Measure cups and spoons
- Jars

Take some time to learn what black walnut (*Juglans nigra*) trees look like and where to look for them. If they live in your habitat, you are in luck and you get to go on a scavenger hunt for these majestic creatures! Not long ago they were very common, but most of the mature black walnut trees have been killed for lumber, valuing short-term profit over ecological health. When you find one, it is a treasure to be grateful for.

Mature black walnut trees are truly magnificent and generous critters.

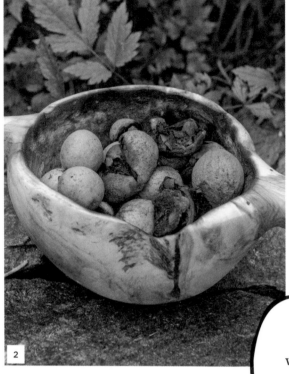

It is the outer fleshy part of the walnut fruit that has all the good pigment in it.

1: GATHER WALNUTS

The trees don't make walnuts every year, but when they do it looks like a tennis ball factory exploded. The squirrels might complain a little but there is plenty to share.

TIP: You can buy black walnut hull powder if walnut trees are not within your bioregion. This form of walnut hull is ideal to work with.

TIP: Fresh black walnut hulls can stain your hands for several days! You might want to wear gloves.

2: SEPARATE THE HULLS FROM THE NUTSHELLS

The hull of the nut is where all the ink is. When they are fresh, the hulls are green and fleshy. When they are dry, they are brown or black. You need to remove the hulls from the nuts by smashing them in a stone mortar and pestle. Once the hulls have been broken, they can be separated from the woody nutshell. Black walnut hulls can stain your hands and clothes if you are not careful (after all, they are full of ink). Use gloves unless you want your hands to be stained for a week!

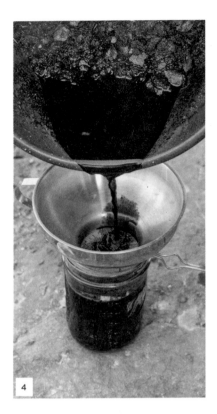

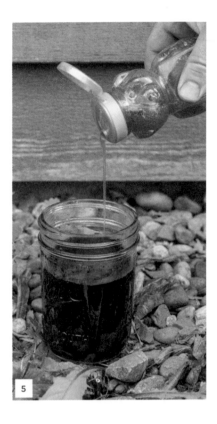

3: SIMMER THE HULLS IN WATER

Fill the pot or slow cooker with hulls and then cover them with water. Simmer the hulls for several hours to several days, depending on how much ink you want to extract from them. Refill the slow cooker with water as needed, being careful not to let it all boil away and burn your ink.

4: REDUCE AND STRAIN THE WALNUT EXTRACT

Continue simmering the hulls until you have about 2 cups (480 ml) of liquid left in the slow cooker. Next, strain the solids. Let the ink cool down before you pour it through a filter to separate out the hull solids. If you want, repeat this process several times with finer filters.

5: ADD A BINDER

This solution will work pretty well as ink in this form, but if you add a binder it will be more satisfying to use. Traditionally, gum arabic was used, but if you don't have that on hand you can experiment with some other sticky things. Honey is a good option. Whatever sticky substance you decide to add in as a binder, I recommend using about 1 part binder to about 8 to 10 parts black walnut brew.

Black walnut ink is a rich and lustrous brown that has a warm sepia feel.

Playing Around: Trying Out Your Ink

Try it out! Use your black walnut ink for drawing, printing, stenciling, writing, even painting. When you are finished, put it away in a container with a tight lid (canning jars work great).

TIP: If you want a darker ink from your walnuts, you can add 1 teaspoon of iron/vinegar solution to each 1 cup (240 ml) of ink. I like to set some walnut ink aside to keep plain and use the iron with the rest.

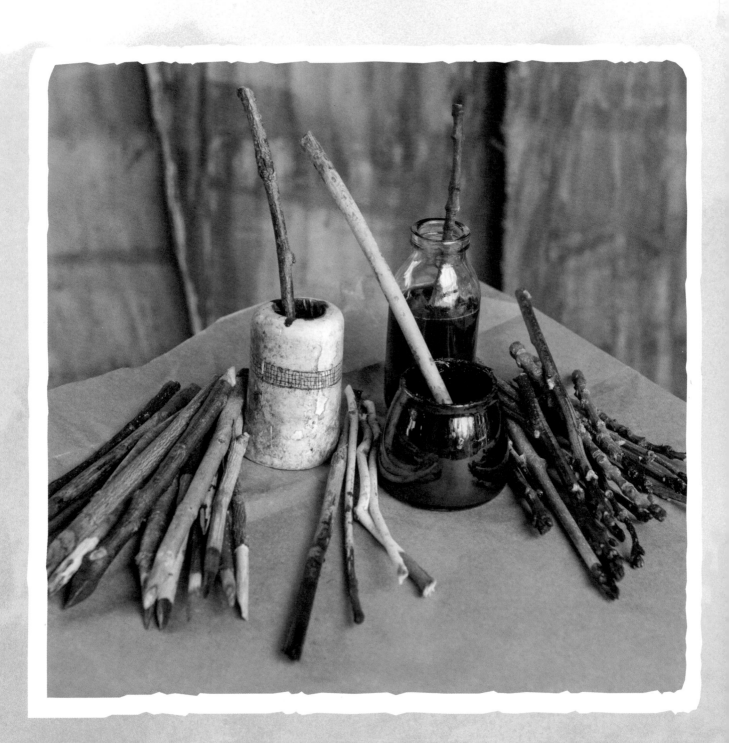

PENS

Old-school pens are called "dip pens." This makes sense when you think about how they work. They're like a combination of pen and paintbrush. They make crisp lines like a modern pen, but you have to "recharge" them with ink, like a paintbrush. That is where all the dipping comes in. With dip pens, the ink is in its own jar, instead of built in to the pen itself. The added step of having to recharge the pen with ink is well worth the inconvenience! You will see why when you start to explore all the cool things your dip pens can do that your fancy modern pens can't. You can make thin wispy lines and thick, bold lines from the same pen. And you can use different tones from the same ink, from dark to light, as the ink flow changes from full to empty.

It is believed that the ancient Egyptians were the first to invent the pen, about 5,000 years ago. Back then they were made out of a reed called sea rush (*Juncus mariti-mus*) and used on paper made from papyrus. Since then, people from all over the world have been making dip pens out of a lot of different things. These days there are all sorts of fancy pens, but the simple dip pen is in its own class, and is still used by creative people every day.

PROJECT : 20 : TWIG PENS

CHALLENGE LEVEL

MATERIALS
· Twigs

Some of my favorite pens that I use for drawing are sticks that I picked up from the ground! In those cases, the only thing that I do to these found objects is dip them in ink and draw with them. Sometimes simple is best.

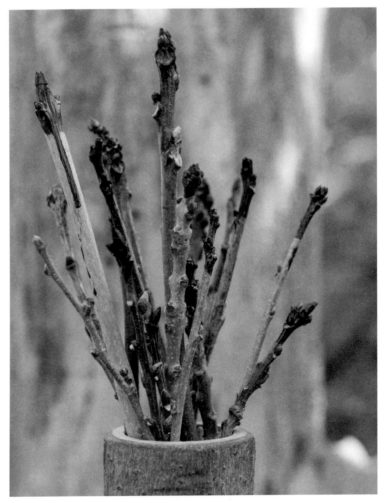

Found objects, such as simple twigs, can work great as dip pens. Experiment!

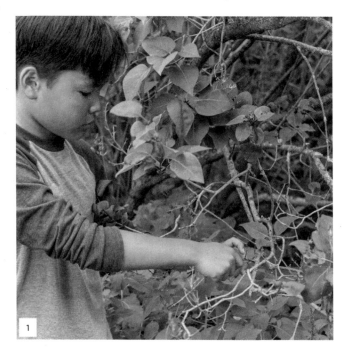

1

Finding a twig pen can be as easy as going out-
side and looking on the ground next to a tree.

Playing Around: Drawing Twigs with Twig Pens

Start a twig collection! Each tree species has a unique twig structure that works differently as a dip pen. Gather two twigs from each tree species in your neighborhood. Use one as a dip pen to draw the other. Be sure to draw them big enough to include the cool details that make each one unique! Before long, you will have two kinds of twig collections: one as pens, and the other as drawings!

1: GO OUTSIDE AND FIND A TREE

Look on the ground under the tree's canopy to find one of the twigs it dropped. Choose one that is as straight as possible and close in size to a common pen.

That's it! The beauty of found dip pens is that you can literally pick them up off the ground. When it comes down to the rocket science of it, any pointy stick-like thingy can be used as a dip pen.

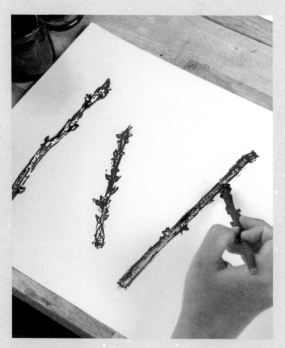

Twig study drawn with found twigs as dip pens.

PROJECT :21: BEAVER PENS

CHALLENGE LEVEL

Some of my favorite found dip pens are actually made by another animal. If you live in a part of the world where beavers also live, you can explore the waterways for some of the fine, pen-size sticks that they collect. When they're finished snacking on the bark they often leave the sticks in the water. The way that the beavers chew the ends of these sticks makes them perfect dip pens! I wouldn't be surprised if archaeologists in the future learn that ancient people may have used beaver sticks in this way, although for now it seems to be just me, and maybe you.

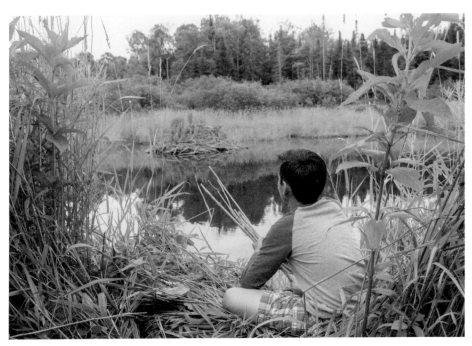

Beavers are impressive landscape architects and they're good pen makers too!

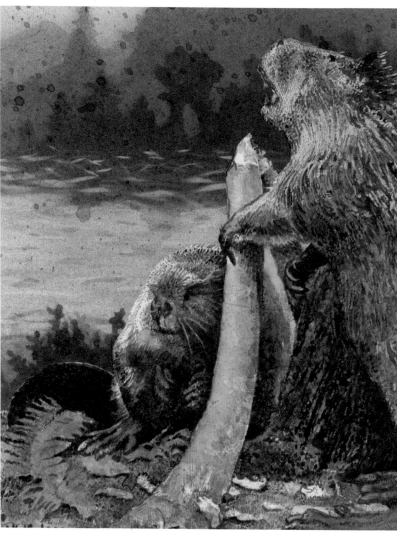

The Engineers, Nick Neddo, willow beaver pen and willow bark ink, stenciled drawing.

SHARP STICK PENS

CHALLENGE LEVEL

MATERIALS
• Stick

TOOLS
• Pruners
• Pocketknife

A stick that is carved into a sharp point, like a sharpened pencil, is fun to make and use as a dip pen. Ancient pens were made by carving sticks into needle-sharp points. This type of dip pen resembles some of the earliest pen technology used by the ancient Egyptians.

Any kind of wood can be used as long as it's not poisonous! I encourage you to make a collection of sharp stick pens from as many tree species as possible.

This project is a fun way to practice carving skills and is great for introducing younger kids to knife use.

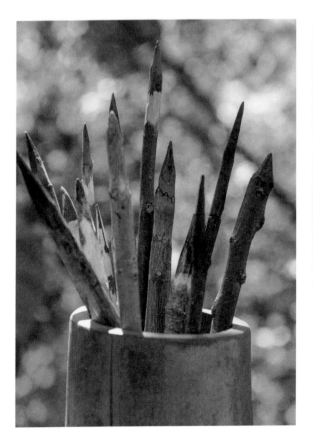

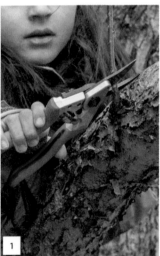

Pruners are perfect for harvesting sticks for your pen projects.

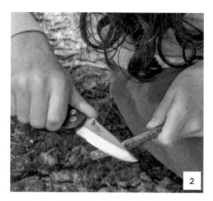
Follow the Knife Safety Standards when you carve.

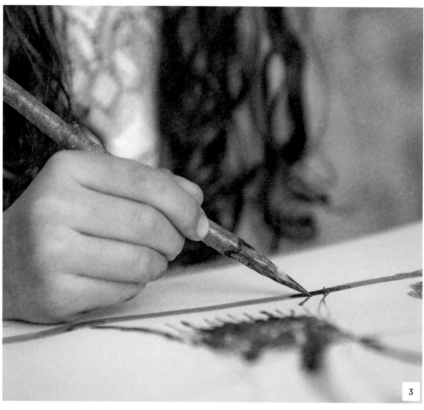
Even a sharp stick can make art.

1: GET A STICK

Find a straight stick, about the size of a pen or pencil. Take this opportunity to help a tree out by taking some small dead branches off with a pair of pruners. Make some observations so you can identify the tree or shrub later if you aren't familiar with it.

2: WHITTLE THE POINT

Use your pocketknife to carve a point on one end of the stick. This can be a long, tapered point or a short blunt point. Try both!

3: INK AND DRAW

The only thing left to do is dip your new pen in some ink and draw with it.

Playing Around: Trying Out Your Stick Pens

Explore what your new stick pen can do. See how many different kinds of marks you can make with it. Notice how the marks you make with a freshly charged pen differ from the marks made when the ink starts to run out. Experiment with the possibilities and have fun drawing with it!

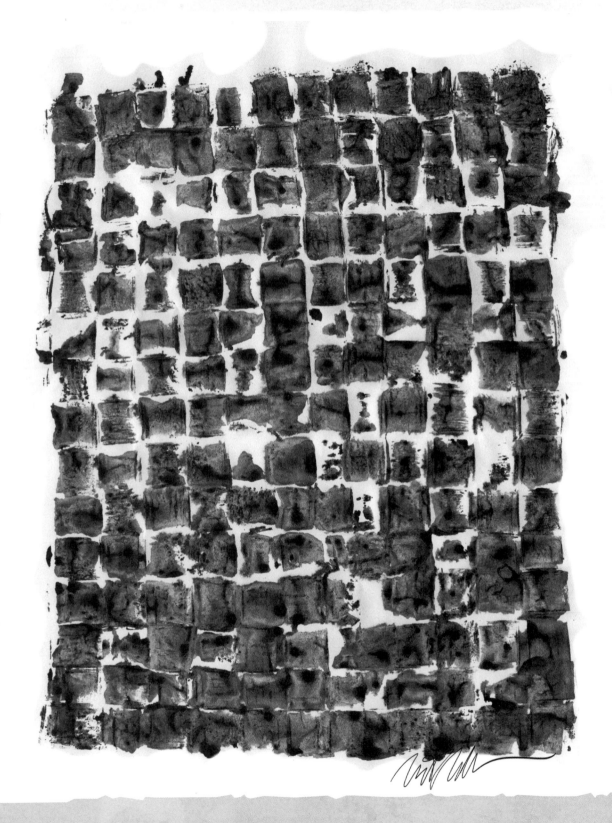

PRINTS, STAMPS & RUBBINGS

Printmaking is the process of making art by printing an inked object on paper or another surface.

Throughout the ages, people all over the world have developed their own unique printmaking styles and techniques. Stone Age caves are decorated with ancient handprints. The woodcut technique was invented in China and Egypt for printing on cloth. In Japan, during the 1600s, a unique style of woodblock printing was developed called *ukiyo-e*. In Europe, from medieval times up to the 1900s, etching was the common printmaking technique, where a drawing is scratched into a surface that gets inked and printed. Printmaking was the first technology for making copies of artwork. Knowledge and ideas were spread faster and further than before because, suddenly, books could be made without writing each word by hand.

Printmaking can be simple or complex, depending on your ideas and how you want to pull them off. This chapter explores printmaking from a special angle, using the endlessly interesting and beautiful objects from nature. There's a lot of different ways to make a print and that's why this medium is so much fun to explore!

PROJECT ⁖ 23 ⁖ HAND PRINTING

CHALLENGE LEVEL

Hands are probably the first things that were printed for creative purposes. Printing with hands has been a popular way to make art since the Stone Age. Some of the oldest examples are found in caves in France, Spain, and Indonesia, going back more than 30,000 years ago, during the last Ice Age.

Hands are beautiful and powerful. They let us make almost everything we can imagine. This is a fun way to celebrate them.

Paper

You can print on all kinds of paper, but they don't all act the same. In general, the best papers for printmaking are the kinds that can hold up to getting wet. I like playing around with watercolor papers, but will use whatever I can get my hands on. Experiment with different kinds of paper.

Inks

One thing that all printmaking inks have in common is that they are sticky or tacky. Add extra honey, gelatin, or glue to the recipes from the inks chapter to modify them for printmaking.

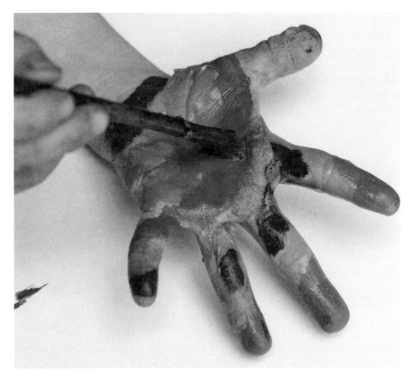

Hands are the original printing objects.

BEET STAMPS

CHALLENGE LEVEL

MATERIALS
- Beets
- Paper

TOOLS
- Knife
- Pencil
- Carving or printmaking tools
- Bowl of warm water

Beets are basically made to be printed with. They are a printing block and ink pad all in one! They make a vibrant natural color that most of us are familiar with, but may not have ever thought of as ink. Like berry inks, the color from beets fade over time.

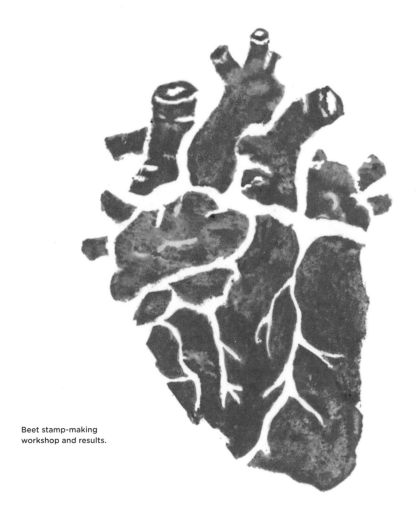

Beet stamp-making workshop and results.

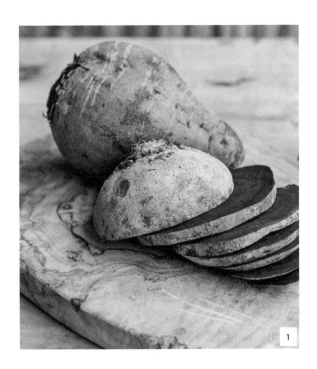

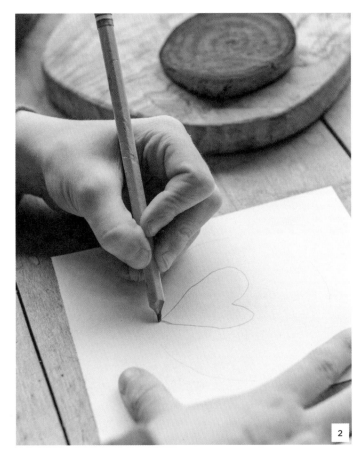

1: SLICE THE BEET

Cut a beet into thin slices, about 3/8 inch (1 cm) thick. The juicier, the better!

2: DESIGN YOUR STAMP

Take a beet slice and trace its outline onto a sheet of paper. Now draw a simple design within the outline. This will be your template for the beet stamp.

TIP: As your beet stamps start to run out of ink, you can recharge them by dipping them in a bowl of warm water. The first few stamps after you recharge will be kind of wet, but then they will be clear and vibrant again.

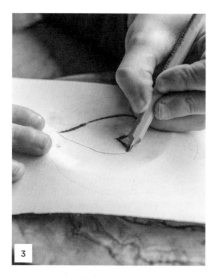

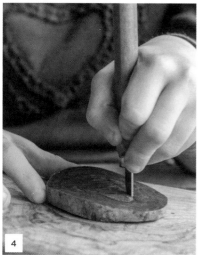

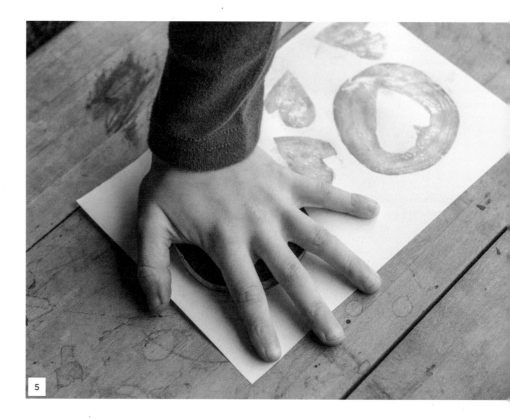

4: CARVE THE DESIGN

Use your knife or printmaking carving tools to cut away the surface of the beet that is around your design. Remember, the parts that you don't carve will be the parts that make a print!

5: PRINT!

Print your stamp onto a piece of paper by putting the carved side down and pressing firmly on the back with your hand. Peel up the stamp and see what it looks like. You can make some adjustments if you want, but remember that you can't put back what you have carved away!

3: TRACE YOUR DESIGN

Put the paper template over the beet slice and use a pencil to trace your template design onto the surface of the beet. This will etch the design into the beet and show you where to carve it.

Playing Around: Potato Prints

You can make stamps with potatoes in the same way as with beets. The one big difference is that you have to add the ink to the potatoes before you stamp them. Use a plate with a little bit of ink on it as your ink pad (or use a readymade ink pad). Carve your stamps and press them into the ink. Then print them onto your art surface!

PROJECT ⁞ 25 ⁞ BERRY SPLAT PRINTS

CHALLENGE LEVEL

MATERIALS

- Newspaper
- Berries (blueberries, raspberries, blackberries, etc.)
- Paper

These prints are extra fun for those of us who have a lot of energy to get out in a creative and productive way! This is another way to play with the natural pigments that berries have in their juicy flesh and skin. I discovered this special way to make prints when I was a kid, and have just scratched the surface of what is possible with making this kind of art.

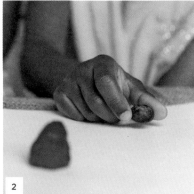

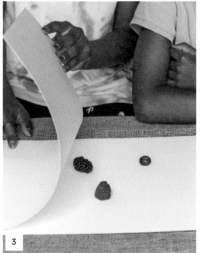

5

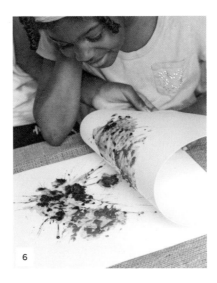

6

1: SET UP YOUR WORK SPACE

Lay down a sheet of newspaper on your work space as a tablecloth. Then put a sheet of paper down in front of you.

2: PLACE THE BERRIES ON THE PAPER

Arrange some berries on the sheet of paper. Don't crowd them, though. For now only use a few.

3: COVER THE BERRIES WITH PAPER

Lay another sheet of paper down on top of the first one with the berries. Make sure that the berries underneath aren't too close to the edge.

4: PUT YOUR FIST IN THE AIR

Make your hand into a fist and hold it high above your head (for extra credit and dramatic effect, you can rotate your arm in a slow, circular motion while making a funny face).

5: SPLAT!

When you are ready, and you can't stand the suspense any longer, quickly thrust your fist down and strike the berries through the top sheet of paper! Be sure to use the soft meaty part of your hand. Go ahead and smash the other berries while you're at it.

6: CHECK IT OUT

When you lift up the top sheet of paper the first thing you will see is berry carnage everywhere. Pick the berry carcasses off your print so you can see what kind of colors and designs you made! You will have two prints, one on the bottom and one on the top.

Playing Around: More Fun with Berries

Experiment with the different colors you can make when you smoosh different kinds of berries. Add layers of color by letting your Berry Splat Prints dry out before you squish more berries on top of the first prints.

To make Berry Splat Stenciled Prints, draw simple shapes on a sheet of paper and cut them out with scissors. Lay this sheet down on top of the paper you are going to print on. Next, place your berries within the cutout shapes. Cover it all with another sheet of paper and print the same way you did before. But this time, when you check your prints, lift off the stencil sheet and you will see a unique berry-splat-stenciled print! You can also use the shapes that you cut out to experiment with in this way.

PROJECT ∶26∶ POUNDED PLANT PRINTS

CHALLENGE LEVEL

MATERIALS

- Flowers and/or fresh spring leaves
- Thick watercolor paper
- Cutting board
- Paper towels
- Painter's tape

TOOLS

- Hammer, rubber tipped (or wrapped with felt)

This printmaking technique uses the natural colors inside plants to make prints on paper. Plant parts, such as flower petals and leaves, are arranged on a sheet of paper and pounded with a hammer. This pushes the plant's juicy colors out and dyes the paper underneath. It is super easy and fun. You don't have to do much work to prepare, you don't need inks or paints, and it doesn't make a big mess to clean up when you are done!

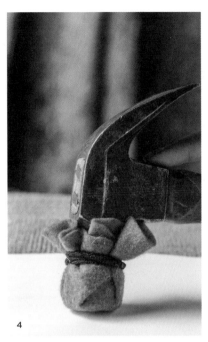

3

Use only fresh plant material for pounded plant prints.

4

Use a rubber hammer or make a pad for a regular carpenter's hammer.

5

1: FIND FLOWERS AND LEAVES

The best time to make pounded plant prints is in the spring-time, when the plants make more of their pigments. Make sure you only pick a little bit from each plant so they don't get too stressed out.

2: SET UP YOUR WORK SPACE

Put a sheet of thick watercolor paper down on top of a cutting board.

3: PLACE A LEAF

Put a leaf (or flower petal) down on the sheet of watercolor paper and then cover it with another sheet of paper and three or four layers of paper towels. Make sure the paper towel layers are larger than the plant. Tape the paper towel layers to the paper with painter's tape (this keeps the plant from moving around).

4: PREPARE THE HAMMER

Cut a circle of felt and attach it to the head of a hammer with string or a rubber band. This will make a pad that can pound the plant without destroying the paper or image.

5: POUND!

Use the hammer to pound the leaf through the layers of paper towels. Start out soft and pound straight down, hitting with the flat part of the hammer with every strike. Hit every area of the plant, and don't miss the edges. When you have lightly pounded the entire plant, do another round of pounding, adding slightly more force.

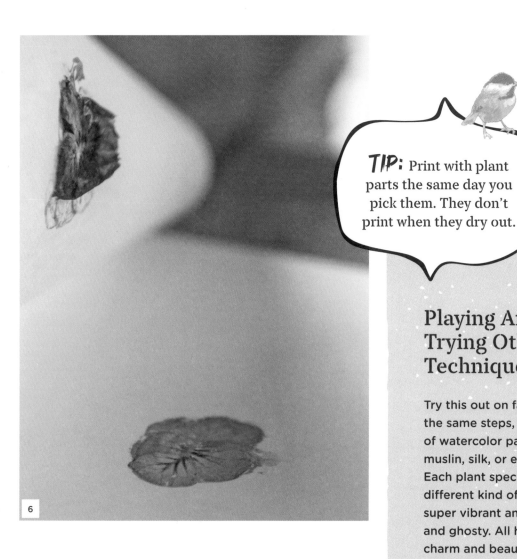

6

TIP: Print with plant parts the same day you pick them. They don't print when they dry out.

Playing Around: Trying Other Techniques

Try this out on fabric. Follow all the same steps, except instead of watercolor paper use cotton, muslin, silk, or even thin wool. Each plant species will give you a different kind of print. Some are super vibrant and others are faint and ghosty. All have a unique charm and beauty.

How many plants can you fit onto one piece of watercolor paper? Can you think of fun ways to experiment with stenciling in this technique? Which plants in your habitat work the best for pounded plant prints? How many colors and shapes can you find from a single plant? There is so much fun waiting for you with all the creativity that's possible! With practice, you will come up with your own techniques.

6: CHECK IT OUT!

Take the tape and paper towels off and then carefully pick the smashed plant bits off the paper. You have just made your first pounded plant print! High five!

LEAF RUBBINGS

CHALLENGE LEVEL

MATERIALS
- Paper
- Charcoal sticks or crayon
- Leaves

TOOLS
- Clipboard

Even the flattest things have little bumps, ridges, and valleys. One of the ways to see these tiny textures is by making a rubbing from them. Rubbing is a simple and fun way to record textures onto a piece of paper as an image. This technique was developed as an art form, called *frottage*, by artist Max Ernst in the 1920s. You don't need ink or paint to do it, just some paper and a stick of artist charcoal, a pencil, or a crayon.

Every tree's leaves are unique and interesting, each with their own shapes and line patterns. This project gives you a great way to see some of nature's finest details and get to know the trees in your neighborhood at the same time.

There is something really cool about "harvesting" textures from the landscape and using them in your artwork!

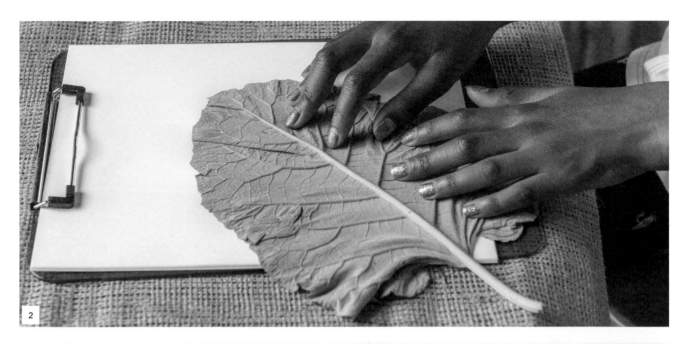

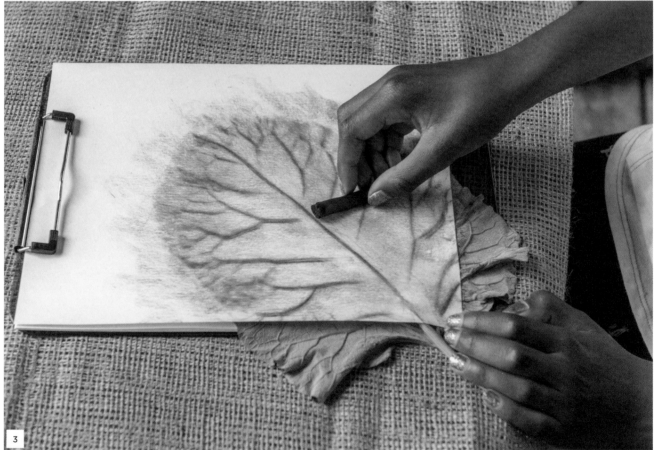

Start out with light pressure as you rub back and forth on the paper over the leaf.

1: MEET A TREE

Grab your clipboard, a few sheets of paper, and some artist charcoal. Go outside and find a tree with a branch that you can reach from the ground. Now go to the end of that branch where all the leaves are.

2: CHOOSE A LEAF

Clip a piece of paper onto the clipboard. Now carefully pick a leaf from the twig and sandwich it between the clipboard and the sheet of paper, with the underside of the leaf facing up. Press the paper down firmly and flat against it.

3: MAKE A RUBBING!

Use the long side of a stick of artist charcoal and lightly rub back and forth on the paper, directly over the leaf underneath. Rub from different directions and slowly press down a little bit harder as you rub. You should immediately see some of the subtle patterns in the leaf show up on your paper!

Playing Around: Rubbings of Bark and Stones

Make rubbings with tree bark! Find a tree that feels good to wrap your arms around. Hold a piece of paper tight to the tree bark (or better yet, tape it to the tree at the top and bottom edges of the paper). Now use the side of one of your artist charcoal sticks and, with light pressure to begin with, start rubbing over the entire surface of the paper. As you continue, experiment with more pressure on certain areas of the paper to see what happens.

Because rubbing is such a great way to "see" textures, why not use it to record the different natural surfaces of stones too?

Try making a rubbing from a bunch of leaves. Set them up however you want and repeat the rubbing process. Use your leaf rubbings with other techniques (like stenciling, pen and ink, eco printing, etc.) to make multimedia art!

PROJECT ⁙ 28 ⁙ ECO PRINTS

CHALLENGE LEVEL

MATERIALS

- Leaves
- Printer paper
- String
- Water
- Vinegar
- Rusty metal bits, like old nails, railroad spikes, or steel wool

TOOLS

- Old phone book (leaf press)
- Project cooking pot
- Stick or copper pipe
- Measuring cups
- Stove or hot plate
- Tongs

Eco printing is the art of getting the secret colors from inside a plant to come out onto a piece of paper or fabric. We call it "printing" because the colors often show up in the special shapes and designs of the object that gives us the color in the first place. It's possible that people in the past knew how to eco print, but one of the first people in modern times to do this was the artist India Flint, who coined the term "eco print." For this project, we will mostly be using different kinds of leaves from plants, shrubs, and trees.

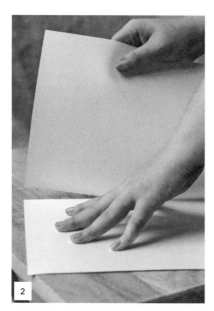

Cut or tear the paper so it can fit in your cooking pot when it's standing up in a roll.

1: FIND LEAVES

Get a collection of leaves from a wide variety of shrubs and trees. Save them between the pages of an old phone book where they can stay flat until you are ready to eco print with them.

2: PREPARE THE PAPER

To begin with, let's use standard printer paper for our first batch of eco printing. Fold each sheet in half and tear it along the seam to make two smaller pieces (most large kitchen pots will fit standard printing paper cut in half). Make a stack of half sheets off to the side and put one piece in front of you on your work space.

Some Eco Printing Species to Try

- Alder (*Alnus incana*)
- Apple (*Malus domestica*)
- Basil/purple basil (*Ocimum basilicum* var. *Purpurascens*)
- Birch (*Betula papyrifera*)
- Black-eyed Susan, brown-eyed Susan (*Rudbeckia hirta*)
- Blackberry (*Rubus fruticosus*)
- Carrot (*Daucus carota*)
- Chokecherry (*Prunus virginiana*)
- Elder (*Sambucus nigra, S. canadensis*)
- Eucalyptus (*Eucalyptus* spp.)
- Geranium, cranesbill (*Geranium maculatum*)
- Goldenrod (*Solidago* spp.)
- Grape (*Vitis riparia*)
- Japanese maple (*Acer palmatum*)
- Lilac (*Syringa* spp.)
- Oak (*Quercus* spp.)
- Pot marigold, Mary bud, Mary's gold (*Calendula officinalis*)
- Purple (red) cabbage, including kale (*Brassica* spp.)
- Rose (*Rosa* spp.)
- Silver maple (*Acer saccharinum*)
- Staghorn sumac (*Rhus typhina*)
- Strawberry (*Fragaria virginiana*)
- Sugar maple (*Acer saccharum*)
- Sweet gum (*Liquidambar styraciflua*)

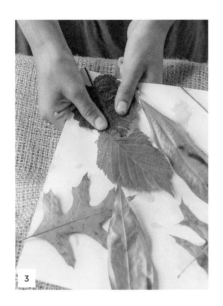 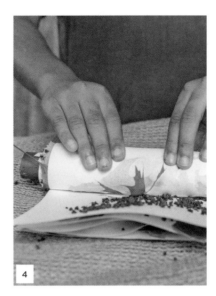 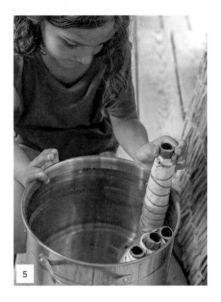

3: ARRANGE THE LEAVES

Put leaves on the sheet of paper in whatever arrangement you want. Next, put a new piece on top of the first. Now put some more leaves on top of this piece, in a new arrangement. Keep doing this, making a paper and leaf sandwich, until the stack is about ³/₈ inch (1 cm) thick. This is one part of the process where younger kids can have complete control and ownership.

4: MAKE A SCROLL

Find a stick (or copper pipe) that is about as big around as a broom handle and cut it into 5¹/₂-inch (14 cm) long pieces. Carefully wrap your paper and leaf sandwich around the stick and tie it into a tight scroll with a long piece of string. Wrap it from one end to the other to make sure the leaves are pressed against the paper and won't fall out. Make as many scrolls as you can fit in your cook pot.

5: PUT THE SCROLLS IN THE POT

Stand the scrolls up in your pot and fill it with water. Add 1 cup (240 ml) of vinegar for each 1 gallon (3.6 L) of water.

6: ADD SOME RUST

Put some rusty metal bits in your pot. You can also use some of the rust juice (1 cup [240 ml] or so) from Project 18) instead of actual metal pieces. This helps bring out some of the darker colors in the natural materials.

TIP: Adding copper to the pot will intensify the colors that show up in your prints.

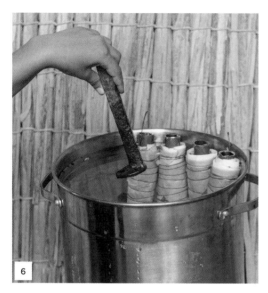

6

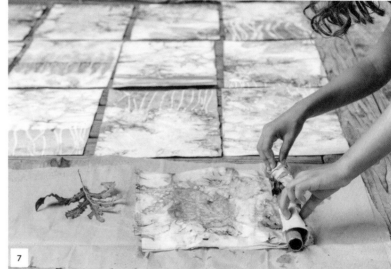

7

7: SIMMER THE WATER

Put the pot on the stovetop or hot plate and let it simmer for 1 hour. Use tongs to pull out your scrolls and let them cool off before you open them up. When you do, get ready! Each sheet of paper will reveal a one-of-a-kind image. Let them dry flat and out of direct sunlight.

Playing Around: Using Your Eco Prints

Your new eco prints are awesome just the way they are. You can hang them up to display them and you can do a lot of other cool things with them too. Some fun ideas:

- Make a drawing on top of your eco prints.

- Write a letter to a close friend on one of your lighter eco prints.

- Use your eco prints to collage.

PROJECT ∶ 29 ∶ NATURE PRINTS

CHALLENGE LEVEL

MATERIALS

- Leaves or other treasures from nature
- Old newspapers or paper bags (kraft paper)
- Paper
- Water-based ink or paint

TOOLS

- Large book (a phone book is good)
- Glass or plexiglass (glass from old picture frames is good for this), for an ink plate
- Tweezers
- Brayer
- Tape (optional)

Nature printing is the process of copying shapes and textures of natural objects onto a sheet of paper with ink or paint. The oldest forms of printmaking, handprints on cave walls, are examples of nature printing. Nature printing can be as easy as painting a leaf with your fingers and stamping it onto a piece of paper. The fancy details and techniques described next will help you refine your nature-printing process, but don't think that you are "doing it wrong" if you decide to do it a different way. Not only does that simple process provide endless opportunities for creative exploration, but it is also a cool way to learn about plants and trees.

Nature printed red oak leaf with striped maple bark

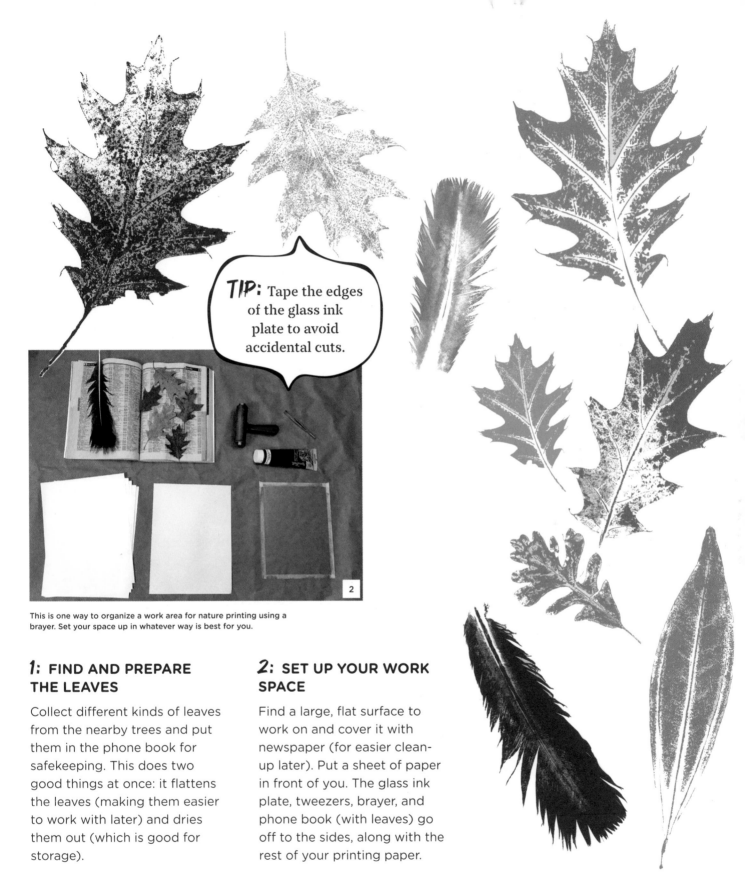

TIP: Tape the edges of the glass ink plate to avoid accidental cuts.

This is one way to organize a work area for nature printing using a brayer. Set your space up in whatever way is best for you.

1: FIND AND PREPARE THE LEAVES

Collect different kinds of leaves from the nearby trees and put them in the phone book for safekeeping. This does two good things at once: it flattens the leaves (making them easier to work with later) and dries them out (which is good for storage).

2: SET UP YOUR WORK SPACE

Find a large, flat surface to work on and cover it with newspaper (for easier clean-up later). Put a sheet of paper in front of you. The glass ink plate, tweezers, brayer, and phone book (with leaves) go off to the sides, along with the rest of your printing paper.

3

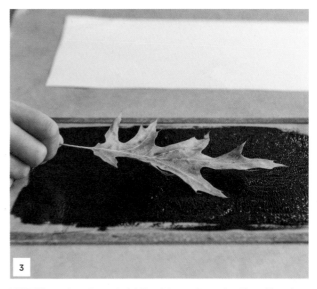

3

LEFT: When using a brayer to ink the plate, use forward motion with each roll. Going back and forth leaves thick and thin ridges of ink on the plate.

ABOVE: Place the leaf in the center of the freshly inked plate.

TIP: When rolling ink on the glass plate you know that the consistency is right when it makes a hissing sound. If it makes a squishing sound there is too much ink on the plate.

3: INK THE LEAF

Put a little bit of ink on the glass and use the brayer to roll it out into a thin layer so that it is bigger than the object you're printing. Take a leaf from the book and place it in the middle of the inked area. Roll ink onto the leaf, making sure to cover the entire surface evenly, including the outer edges. Turn the leaf over with the tweezers and repeat the inking process.

The idea is that the leaf has the right amount of ink on both sides. Not enough ink results in a light print missing the fine details; too much ink creates a dark print with details squished away into a blob. This is something that you will have to play with to get a feel for.

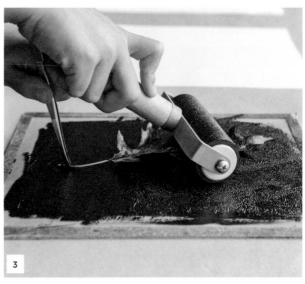

3

Roll ink onto the leaf from the middle out to the sides.

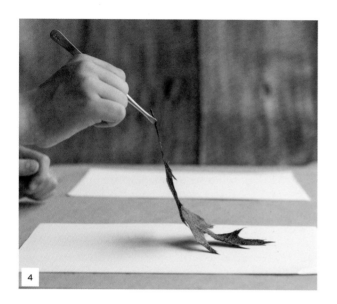

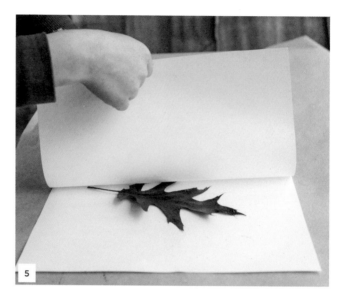

4: PLACE THE LEAF ON THE PAPER

Use tweezers to pick up the inked leaf and carefully place it on the paper in front of you. Wherever it lands on the paper is where it should stay. If it moves around on the paper it will make a double image or a smear.

5: PRINT!

Cover the inked leaf with another sheet of paper and use the fingers of one hand to anchor the leaf in place between the two sheets. With your other hand, rub the leaf through the back of the top piece of paper. Use firm pressure and be sure to touch every part of the leaf through the paper, finding all the fine textures with your fingers.

TIP: Use enough pressure to keep the leaf and paper in place, but not so much that your fingers leave dark ink splotches in the center of your print.

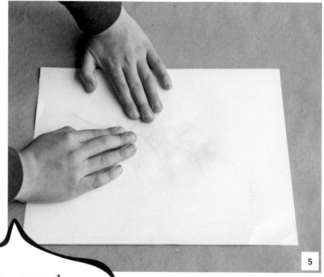

Press the leaf down through the paper with one hand to keep it from moving and rub over the surface of the leaf with your other hand.

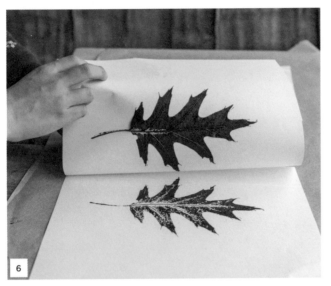

6

Lift up the top sheet of paper to see the first print. Use tweezers to pick up the leaf and see the second one below!

6: REVEAL YOUR PRINT

Roll back the top sheet of paper to see your print! Sometimes the leaf will stick to the top sheet, so watch out for that. This is the part where we get direct feedback from the printing process itself. Did we use the right amount of ink and pressure? The print will answer these questions if you pay attention.

TIP: Make several prints each time you set up for nature printing. The masterpiece often doesn't arrive until the third or fourth print from the same leaf.

Playing Around: More Ideas for Nature Printing

- Try inking printable objects with a pump sprayer or paintbrush. These are good for printing things that aren't flat.

- Try printing with different colors and home-made paints.

- Experiment with different kinds of paper. Thin paper acts differently than thick paper.

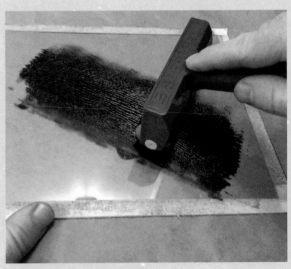

Experiment with sprayers, paintbrushes, handmade ink, and brayers for inking printable objects.

Nature printing is a lot of fun for kids of all ages!

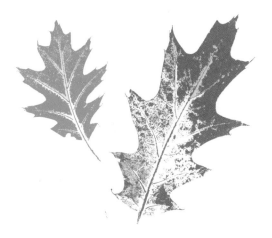

STENCILS

The last projects in this chapter are in a special category of print-making that deserves its own introduction.

A stencil is a form of "resist." A resist is something that you put on (or in front of) a surface before adding color to it. When it gets colored, the stencil blocks the pigment from reaching the areas underneath. Think of a stencil as a shield that protects the paper from getting "hit" by color. Everywhere around the "shield" gets colored, but the parts underneath the "shield" don't.

Stencils can be found objects, like hands and leaves, or they can be made by cutting shapes out of paper or cardboard. Stencils are super fun to make and use!

HAND STENCILS

MATERIALS
- Paint or ink
- Newspaper (optional, if working inside)
- Paper

TOOLS
- Spray bottle or paintbrush

The oldest stenciled art that we know of was made during the Stone Age. People put their hands against a rock wall and sprayed them with paint. Some of them were even made with the hands of toddlers! The images these ancient artists made are powerful and beautiful. Some are a single stenciled hand, while others are complex patterns of overlapping hand stencils. However you decide to do it, you're sure to make some hand-some prints!

Ancient stencil art from the Ice Age. Chauvet Cave, France.

1: FIND YOUR HANDS

They should be where you left them.

2: MAKE SOME PAINT OR INK

See Projects 3, 4, 17, or 18.

3: SET UP YOUR WORK SPACE

If you are working outside, great! You just need to hang your paper up somewhere (maybe tacked to a shed wall) or flat on a table surface. If you are inside, lay down some newspaper as a tablecloth so you don't make a big mess. Now, put a sheet of paper down on top of the newspaper.

4: SPRAY PAINT

If you are using ink, put some in a spray bottle and add a little bit of water. Now press your hand flat against the paper and keep it still. With your other hand, pick up the spray bottle and squirt all around your hand. Lift up your hand to see how your stencil looks! If you are using paint and a paintbrush, follow the same steps, except press your hand more firmly against the paper while you use the paintbrush to paint around your hand and in between your fingers.

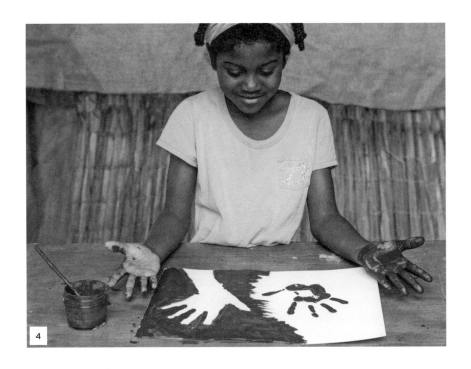

4

Playing Around: Making Designs

Try using different pigments for your colors. Try it with artist charcoal. Try it with different colors of paint. Try it with crayons. Try it any way you want to!

Make some stenciled art with at least seven different colors or mediums, and as many hands as you want. How many different designs can you make with stenciled hands? Can you make your hands look like something else?

Try out different kinds of paper too! The colors you use to stencil with will all act slightly differently with each kind of paper.

PROJECT ÷ 31 ÷ FOUND OBJECT STENCILS

A fancy art term for stenciling with three-dimensional objects is *aerography*. This technique uses ink or paint to spray around an object to make super unique stencil effects.

One of the really cool things about aerography is the variety of lines and edges that you can make. Sometimes you end up with a realistic image of the object, and other times you get a more abstract and dreamy impression. This is probably why it was popular with some surrealist painters in the 1900s.

These can be flat, like leaves, or whatever-shaped, like whatever. With a little practice you will know how much fun it is to experiment with the endless possibilities of stenciling with found objects.

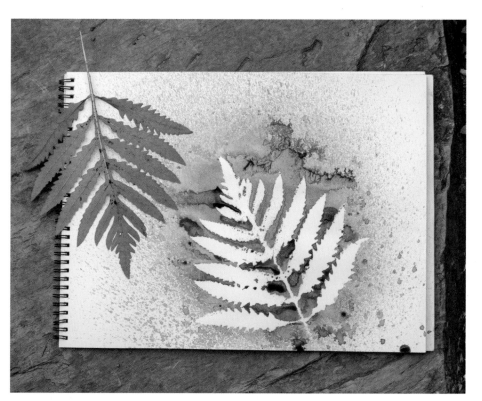

Found stencils and the images they made.

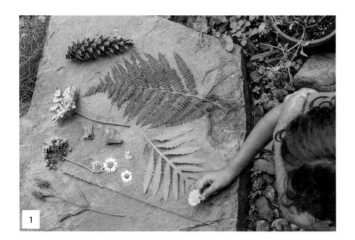

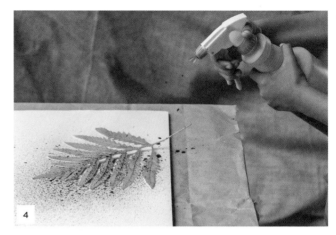

Objects can be stenciled all at once or in layers.

1: GO ON A TREASURE HUNT

Collect interesting things from outside. Bring a bag with you and put a bunch of different things in it. Keep your eyes out for pine cones, leaves, flowers, sticks, twigs, feathers, and other things with interesting shapes. Just don't pull a whole plant out of the ground! You don't need to kill anything for this project. Bring your treasures back to your work area.

2: SET UP YOUR WORK AREA

Use some newspaper as a tablecloth to make cleanup easier later. Now put a piece of paper on top of the newspaper.

3: LOAD THE SPRAY BOTTLE

Put some ink into the spray bottle. If the ink has a lot of sediment in it, pour it through a fine filter (like a bandana or an old T-shirt) first. Also, if the ink is thick like syrup, add a little bit of water to thin it out. This is true for paint too.

4: ARRANGE THE OBJECTS

Put the nature treasures on the sheet of paper and spray them with ink. Spray from different directions to capture more details in your image. Lift up your objects to see your stencil image!

TIP: When spraying paint onto a stencil object, play around with how close the object is to the paper. If it's close, the lines will be hard and crisp. But if the object is up off the paper a little bit, the lines will be soft and diffused.

Playing Around: Multimedia Stenciling

Use some flattened leaves to make stencil art. Arrange the leaves on the paper however you want, with some facing top up, and others with the underside facing up. Use a spray bottle to ink them. Now, carefully turn over a leaf and print it in its own stenciled spot. Do this with other leaves and see what kind of cool patterns you can make!

PROJECT ÷ 32 ÷ CUTOUT STENCILS

MATERIALS

- Pencil or charcoal drawing stick
- Cardstock or paperboard
- Ink or paint (see Projects 3, 4, 17, or 18)
- Paper
- Old newspaper

TOOLS

- Craft knife
- Cutting board
- Scissors
- Spray bottle

Cutout stencils are handmade from thin sheets of material, usually cardstock, cardboard, plastic, or metal. As you might have guessed by the name, designs are cut out from these thin sheets and placed on the surface that gets stenciled. For centuries, artists around the world have used cutout stencils to illustrate books, decorate cloth or wood, color prints, and make playing cards. It's a popular medium for many street artists too.

This kind of stenciling opens up a world of creative possibilities because you can invent your own stencil patterns!

A collection of cutout stencils and the art they made.

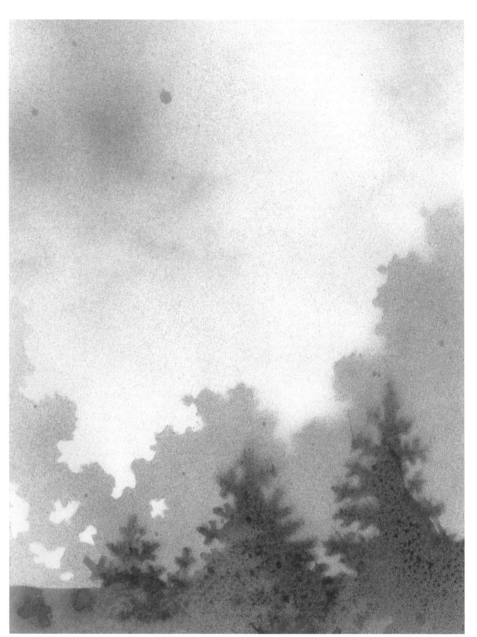

1: DRAW SHAPES

Draw the shapes for your stencil design on a piece of cardstock. Make them pretty simple at first (you can always make them crazy later). These can be imaginary, abstract shapes or they can be modeled after real-life things. It's totally up to you.

2: CUT OUT THE SHAPES

Cut out your shapes, using the lines that you drew as your guide. If your design has a lot of detail, place the paper on the cutting board and use the craft knife; otherwise, just use scissors.

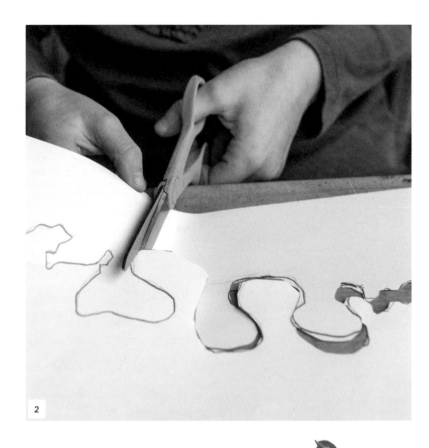

2

TIP: Keep the pieces that you cut from your original stencil design. These can be used as stencil pieces too.

3: LOAD THE SPRAY BOTTLE

Put some ink in the spray bottle. If the ink has a lot of sediment in it, pour it through a fine filter (like a bandana or an old T-shirt) first. Also, if the ink is thick like syrup, add a little bit of water to thin it out. This is true for paint too.

TIP: Flip your stencil over and use the other side too! This will give you two designs in one, one a mirror image of the other.

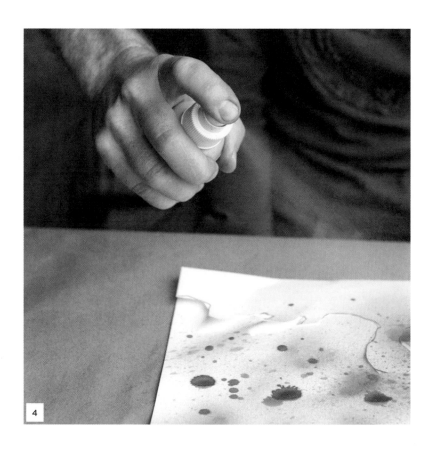

4

TIP: If you want to reinforce your stencils to use again and again, paint both sides of it with waterproof wood glue. When it feels mostly dry, press it flat so it doesn't curl up.

4: SPRAY IT!

Set a piece of paper down on some old newspaper to protect the table. Set your stencil on top of the paper and then spray it with the ink. Now lift up your stencil to see how your design looks! Experiment with moving the stencil around on the paper and spraying more layers of ink onto your design. Try it with charcoal sticks, paint and paintbrushes, with crayons, and even with pens. Play around to explore what's possible!

Playing Around: Build a Stencil Library

I have a box that I keep all of my cutout stencils in. This is my stencil library! You can build and decorate your own stencil library too. When you clean up after using new stencils, put them in a folder or box with your other stencils, so you can use them again for other projects. Remember to store them flat so they don't get warped. I even like to add each stencil's image to my stencil library box. This makes the box itself a work of art that is always changing!

PAPIER-MÂCHÉ

Papier-mâché is a sculptural material made out of scrap paper and glue. It is a cool way to transform old newspaper, junk mail, and cardboard into three-dimensional works of art. There are two general ways to make it. Both techniques involve mixing some sort of glue (usually wheat paste or white glue) with paper and sculpting it onto a form (called an "armature"). One technique uses strips of paper and the other uses re-pulped paper called "paper clay." Some artists use one technique, and others combine both into a single project.

Some people think that papier-mâché was invented in France (it literally means "chewed paper" in French), but artists in China were making cool stuff with it way before anyone else. Paper was invented there 2,000 years ago, so it is no surprise that papier-mâché was developed there too. It has been widely used all over the world to make cool stuff ever since.

The options are pretty much endless with what kinds of forms you can make. If you can imagine it, you can build it with papier-mâché!

PROJECT ꞉3 3꞉ MASK WITH PAPIER-MÂCHÉ STRIPS

CHALLENGE LEVEL

MATERIALS

- Newspaper or other scrap paper
- Masking tape
- All-purpose flour
- Water
- String

TOOLS

- Mixing bowl
- Spoon or whisk
- Scissors

Making and using masks is probably one of our original art forms. Almost every natural material imaginable has been used to make masks, but the only ones that have survived the ages are made out of stone. The oldest ones that we know about are 9,000 years old (from the Judean Hills of present-day Jerusalem). We will never know when the very first masks were made, because they turned to dust long ago. But we can safely say that people have been making masks for a long time.

This project is an introduction to basic papier-mâché crafting. Through the process of making a mask, you will learn the techniques you need for most papier-mâché work. What you learn next will be the foundational skills for the papier-mâché projects that come after.

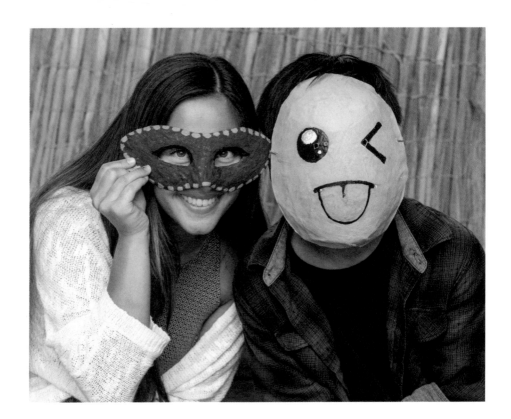

1: FIND OR BUILD THE ARMATURE

Since our faces aren't flat, the object you use to build your mask around needs to be slightly curved. You can use a watermelon, large squash, or the right size log if you don't want to custom build your own armature. But for this project we will use crumpled-up newspaper and tape because it will introduce skills that you will need later.

Armatures

The armature is the basic form that you build your papier-mâché onto. Think of it as the body of your project, while the actual papier-mâché is the skin or exoskeleton. An armature can be as simple as a crumpled-up ball of newspaper, a cardboard box, or a stick. It can also be as complicated as a frame of interlocking parts made from wood, metal, rescued trash, recycling, inflated balloons, or whatever else you decide to layer paper and glue over.

Some projects use a temporary armature that you take out later (like when making a mask). Other projects require one that's built in, making a skeleton that gives permanent support. This is usually the case with complex projects, like large sculptures.

Sometimes you can't find the right object for an armature and you have to make one yourself. Old newspaper and a roll of masking tape is all you need to make nearly any shape and form you want. Add cardboard to your list of materials and anything is possible! Play around with these techniques:

- Crumpling: using crumpled balls of paper individually, taped together, or stuffed in a paper bag

- Twisting: making long coils or snakes of crumpled and twisted paper

- Wrapping: using a sheet of newspaper to bundle and package crumpled balls or twists of paper

Use masking tape or twine to hold your crumpled and twisted shapes together. Keep doing this until you have the overall shape you want.

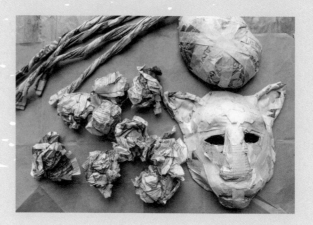

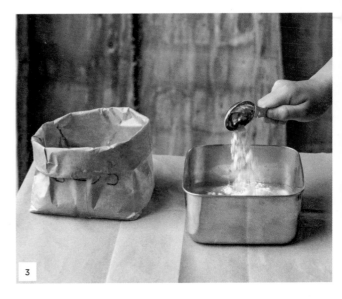

2: TEAR THE PAPER INTO STRIPS

Any old paper will do, but newspaper is easy to find and make into long strips. Separate some pages out from the rest and hold them where they are folded. Begin tearing from that crease, making strips 3/4 to 1 1/2 inches (2 to 4 cm) wide. Make a small pile of these to get started. Don't worry about making all that you need right now. It is easy enough to make more as you need them.

3: MAKE THE PASTE

The ratio of flour to water is about 1 to 1, but the quantities depend on how much you need for your project. Let's start out with 1 cup (120 g) of all-purpose flour and 1 cup (240 ml) of water.

Pour a little flour into a bowl and add a little water, mixing them together with the spoon, whisk, or little hands. When the clumps disappear, add more flour and water until a full cup of each is mixed together without clumps.

The consistency can vary depending on your preference. Some artists like their papier-mâché paste to be like white glue, some prefer it like pancake batter, and others like it thicker; it all works.

TIP: The goal is to make enough paste for your project without having too much left over. Flour paste doesn't store well because it loses its stickiness and starts to smell funky (the stinky kind) as it sits around.

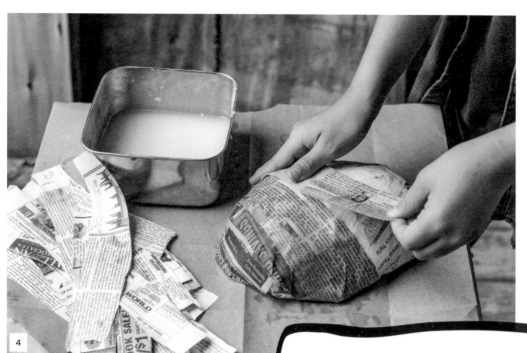

4

4: MAKE THE FIRST LAYER

Set your armature on your work surface and lay a few sheets of newspaper over it. This makes it easier to take the finished mask off later without messing up the armature (in case you want to use it again).

Take a strip of paper and dunk it into the bowl of wheat paste. Now pull it out, and run it along the edge of the bowl to squeegee out extra liquid. Lay the wet strip of paper down on the mask armature, starting at the top. Repeat this with a second strip of wet paper, this time overlapping the first strip by about half of its width.

TIP: Put your papier-mâché project somewhere where it can dry out quickly, such as in the sunlight or near a fan or heat source while you wait to add more layers. If you cover a wet layer with another wet layer it might mold. It's best to play it safe and let each layer dry completely before moving on.

As you add more strips from top to bottom, each one covers part of the last one. Be sure to gently press each overlap firmly so it all sticks together well. When you have covered the entire armature, it is time to let it dry before adding the second layer.

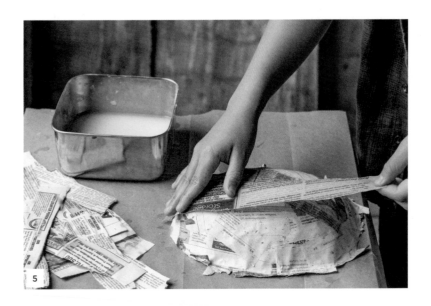

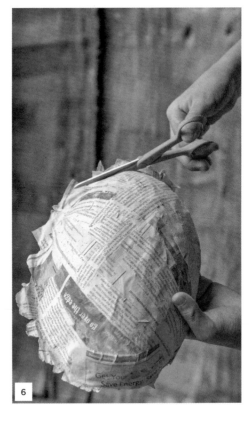

5: ADD THE NEXT LAYER

Once the first layer of papier-mâché has dried completely, repeat the previous step. This time, though, lay the wet paper strips down crosswise (perpendicular) to the strips in the first layer. This "crosshatching" approach will make your mask tough! Again, let it dry out completely and then lay down a third layer, perpendicular to the second one. You can add as many layers as you want. The thicker it is, the stronger and more rigid it will be. But if you lay the strips as I have explained, three layers should be strong enough.

6: TRIM THE EDGES

When the final layer has dried and become firm, you can take it off the armature. If you are careful not to destroy the armature it can be used again to make more masks. Use scissors to cut the jagged bits from the edge of the mask so the "rim" is a nice smooth line. Next, use short papier-mâché strips to line the rim, folding the strips in half on the rim edge so that one half is on the inside and the other half is on the outside. This is a nice touch that makes the mask stronger as well as more comfortable to wear.

TIP: Wash the bowl and spoon or whisk as soon as you are finished working. The paste dries hard and is way easier to deal with before that happens!

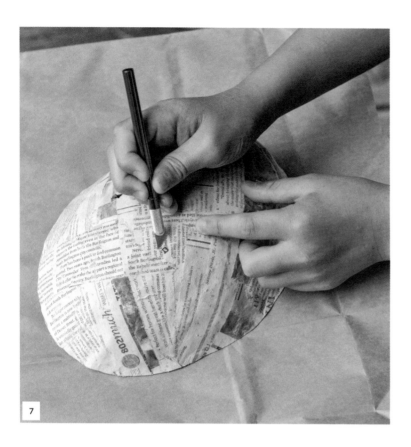

7

7: ADD EYEHOLES AND STRING

Use sharp scissors to cut eye-holes in your mask so you can actually see when you wear it. Make a mark where you think each of the eyes should be and poke a hole there with the scissors. Try it on before you cut the holes bigger so you know what shape to make them for the best visibility. Now snip the eyeholes how you want them! Finally, add a piece of string to the back so your mask stays snug to your face.

Playing Around: Adding Paint

This is a great project to decorate with your handmade paint! The recipes in Projects 3 and 4 will work well and look super cool on your new mask. Give the mask at least two coats of paint to cover up the newspaper ink below.

Use papier-mâché strips to make custom wraps for your handmade crayons (Projects 14 and 15). This is a cool way to protect them and make them look fancy!

PROJECT ⋮ 34 ⋮ MAKE PAPIER-MÂCHÉ CLAY

CHALLENGE LEVEL

MATERIALS

- Water
- Old newspaper
- All-purpose flour
- Salt
- Rosemary or clove essential oil (optional)

TOOLS

- Two 5-gallon (18 L) buckets
- Long stirring stick
- Immersion blender, power whisk/ mixer, or handheld power drill with mixer attachment (optional)
- String or strong rubber band
- Old T-shirt
- Measuring cups and spoons
- Large bowl

This kind of papier-mâché is a clay-like material that is made from small pieces of shredded paper, soaked in water, and then pulped. This pulp is mixed with a paste and then kneaded like bread dough until it feels like clay. It is great for adding fine details and structure to projects made with the basic paper strip method (see Project 33).

Sculpting with papier-mâché clay opens up a ton of creative opportunities! There are a lot of recipes, but I think the simple ones are the best.

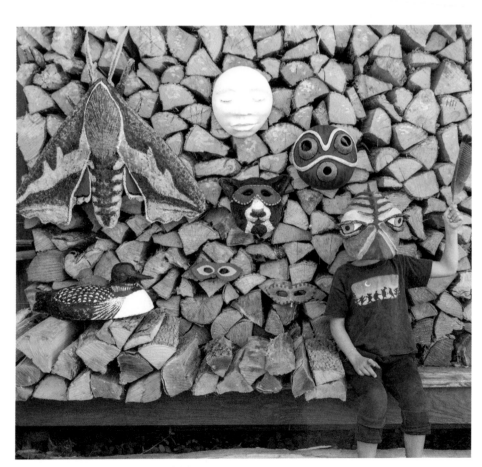

Papier-mâché clay is next level papier-mâché!

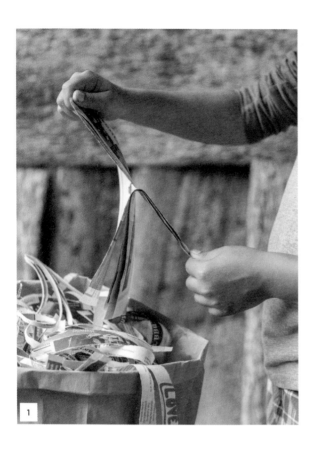

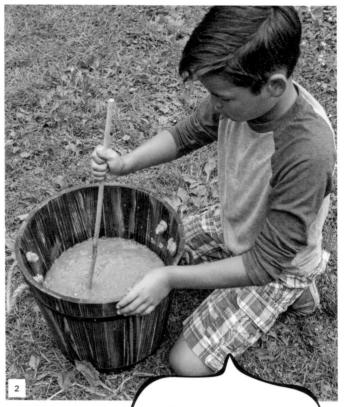

1: SHRED SOME PAPER

Put about ½ gallon (1.8 L) of hot water in one of the buckets.

Now tear a few sheets of newspaper into extra-thin strips and put them in. Any scrap paper will work, but newspaper is the best because it turns back into pulp easily. Stir the mixture with a stick or long handled kitchen spoon each time you add more shredded paper to the bucket.

TIP: The skinnier these strips are, the easier they will turn back into pulp.

TIP: You can speed this process with an immersion blender or power whisk.

2: STIR AND SOAK

Add another ½ gallon (1.8 L) of hot water and stir the paper and water until each shred of paper turns into pulp. This takes a little while. Let it sit overnight and mix it up often.

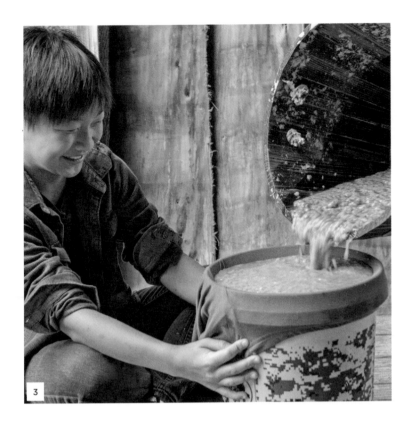

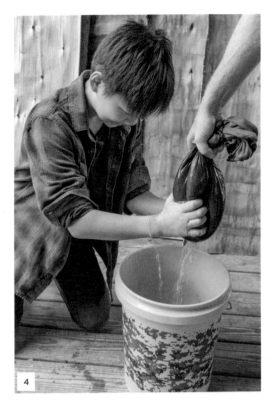

3: STRAIN THE PULP

Use string or a strong rubber band to tie an old T-shirt over the opening of the second (empty) bucket. Next, pour the extra water from the pulp bucket through the T-shirt and into the second bucket. The fabric will act as a strainer and catch the pulp.

4: WRING IT OUT

When all the pulp is caught in the T-shirt strainer, untie it from the bucket and pull it out as a pouch. Squeeze it from the outside to wring out most of the water that is still in the pulp. Don't worry about every little drop, just get it to stop dripping.

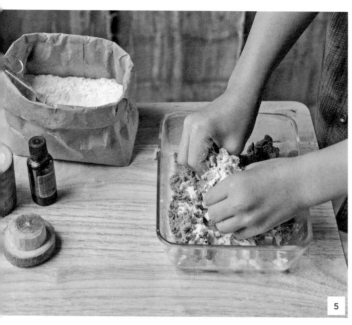

Mix the pulp with flour and salt (maybe some essential oil too) and work it with your hands like bread dough.

5: KNEAD THE PULP

Use a measuring cup to put about 3 cups (720 g) of pulp in a large bowl. Add about 1 cup (120 g) of all-purpose flour and 1 teaspoon of salt. Mix these all together with your hands. Focus on breaking apart the clumps as you knead the paper clay. Do this until it is all the same consistency.

TIP: Add a couple drops of rosemary or clove essential oil in with your paper clay mix. This will help keep mold from growing on your creations, especially if you live in a humid environment.

TIP: Try to make a little bit of the paper clay into a worm, or coil. If it doesn't fall apart or stick to your hands, it's ready to work with. But if the paper clay is too wet you can add more all-purpose flour and/or baking soda and/or fine sawdust to make it feel more like workable clay.

Playing Around: Experimenting with Different Gluey Stuff

Each of the following gluey substances has its own characteristics when mixed and kneaded with paper pulp. Depending on your needs, one might be better than another. Play around with these different options and maybe you will discover a new recipe for papier-mâché clay!

- White glue: About ¼ cup (60 ml) for each 1 cup (240 g) of paper pulp

- Cornstarch: About ¼ cup (30 g) for each 1 cup (240 g) of paper pulp

- Gelatin: About ¼ cup (30 g) for each 1 cup (240 g) of paper pulp

- Tapioca starch: About ¼ cup (30 g) for each 1 cup (240 g) of paper pulp

PROJECT ⋮ 35 ⋮ PAPIER-MÂCHÉ CLAY MASK

Because masks are so cool, we will do another project to learn about papier-mâché clay. You can add on to the mask from Project 33, or start a whole new one.

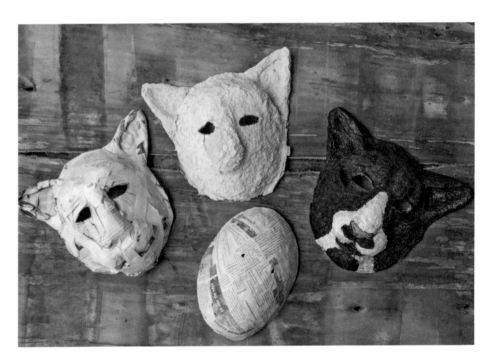

Papier-mâché clay masks in different stages of creation.

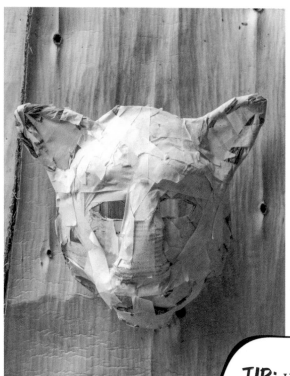

3

Use crumpled and coiled newspaper and masking tape to make mini armatures to build facial features.

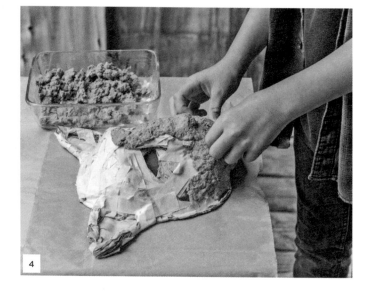

4

1: MAKE A BASIC MASK

Make a mask with the basic papier-mâché techniques you learned in Project 33. But this time, put it back on the armature after you cut out the eyeholes.

2: MAKE PAPIER-MÂCHÉ CLAY

Follow the directions in Project 34 to make a batch of papier-mâché clay to sculpt with.

TIP: Use the masking tape to get the newspaper close to the final shapes you want. It takes a little more time now, but saves you a lot of time later on!

3: MAKE FACIAL FEATURES

Add some features to your mask with crumpled paper and masking tape. Start with the nose. Crumple up a sheet of newspaper into a rectangular ball that's a little skinnier at one end. Now tape it to the mask where you want the nose to be. Make smaller "worms" of crumpled paper for the lips

and eyebrow ridges. In this way, build up the places on the mask that you want to add the most shape to.

4: ADD THE FIRST LAYER

Cover the entire mask with a thin layer of papier-mâché clay. To make sure it dries fast, don't layer it thicker than 3/8 inch (1 cm). It needs to dry completely before you put another layer on. Place it in the sun or near a fan to help it dry faster.

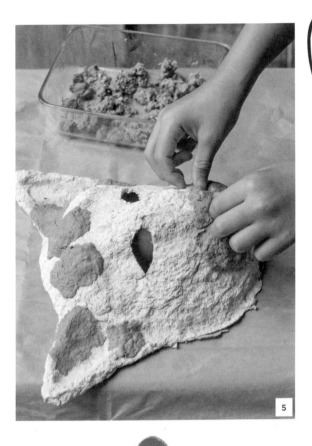

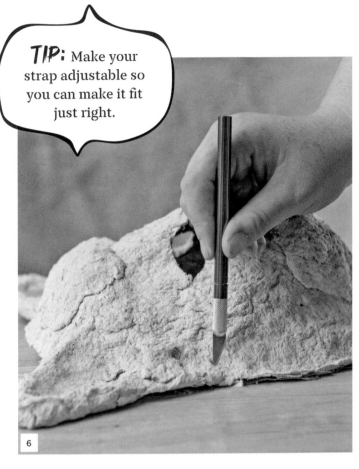

TIP: Make your strap adjustable so you can make it fit just right.

TIP: You can add as many layers as you need in order to get the shapes and details you want.

5: ADD A SECOND LAYER

When the first layer of papier-mâché clay is completely dry, take the mask off the armature. Now is a good time to add another layer to make special details on your mask. Use the papier-mâché clay like clay and add it to parts that need to be built up. Can you make eyebrows? What about cheeks and dimples? How would you make nostrils on your mask's nose? When you are finished with these details, let it dry again.

6: TIE ON A STRING

Use your pocketknife to drill holes along the edges of the mask for the strap. First, mark where you want the holes to be, from the inside. Then put the mask on a cutting board and lightly insert the tip of your pocketknife into the mask, on your marks. With the mask sandwiched between the cutting board and the tip of your knife, use a twisting motion with light pressure to drill a hole. Do this on both sides and then tie a piece of string to your mask as a strap.

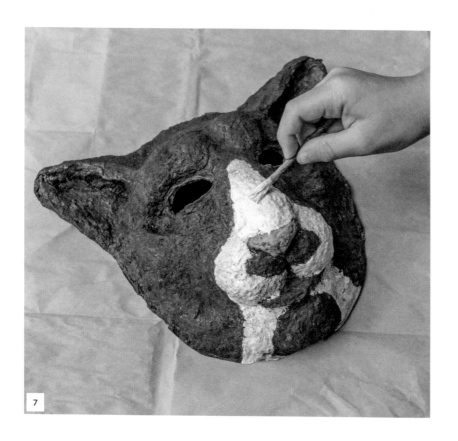

7

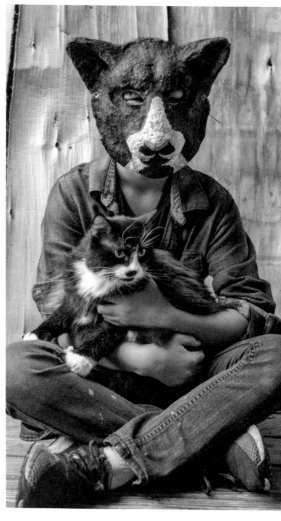

7: PAINT YOUR MASK

Paint your mask with one of the handmade recipes in Project 3 or 4. Make it as colorful as you want. Think about different designs and patterns you might want to use on your mask. And remember, you can always change it later if you want to.

Playing Around

When your papier-mâché mask is dry (before you paint it), you can shape it like a piece of wood. Any woodworking tools will work on papier-mâché. Just make sure the layers are thick enough so you don't make a hole in your project. But if you do, just patch it with papier-mâché clay! Experiment with rasps, sandpaper, gouges, and chisels.

PROJECT ⁘ 36 ⁘ PAPIER-MÂCHÉ ART BOX

MATERIALS

- Cardboard or paperboard box
- Papier-mâché clay (from Project 34)
- Paint (from Project 3 or 4)

TOOLS

- Paintbrush
- Sandpaper

Art materials are important tools in a creative person's life. If your tools don't have a place to live, it can be hard to find them when you need them. You can use any old box to store them in, but why not build your own with papier-mâché? This is a great way to transform a disposable object (a cardboard box) into something that is long-lasting and beautiful.

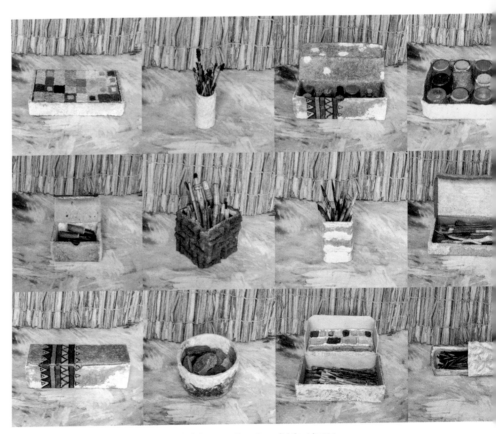

Boxes of all shapes and sizes can be "upcycled" into sweet papier-mâché art boxes.

1: FIND THE RIGHT BOX

Pick a box that will do what you need it to do. If you are just making a home for your crayons or charcoal sticks, use a small box. But if you are trying to fit all of your handmade art tools inside, find something bigger. Does it need a lid? This depends on what kind of life your art box will live.

For desktop art boxes, don't worry about a lid. These can be short and wide, like a tray, or tall and narrow, like a cup. For art boxes that go on adventures, start out with one with a built-in lid that "hinges" at one end, and a tab that tucks in at the other end. These are also good for storage.

2: MAKE SOME PAPIER-MÂCHÉ CLAY

Follow the steps in Project 34 to make a nice batch of papier-mâché clay.

3: ADD A LAYER OF PAPIER-MÂCHÉ CLAY

Add a thin layer of papier-mâché clay to the outside of the box, including the bottom. If it has a lid with a hinge, avoid the crease so the hinge will still work later. Now let it dry. Add another layer if you want to, or move on to the next step.

4: DECORATE YOUR BOX

When the final layer of papier-mâché clay is dry, you can customize your new art box. It can be decorated in all sorts of cool ways, making it a multi-media project. Here are some ideas to play with:

- Stenciling (see Projects 30–32)
- Crayons (see Projects 14 and 15)
- Charcoal (see Projects 10 and 12)
- Paint (see Projects 3 and 4)
- Pen and ink (see Projects 16–22)
- Nature printing (see Project 29)
- Stamping (see Project 24)

Bust out your creativity and give it some color!

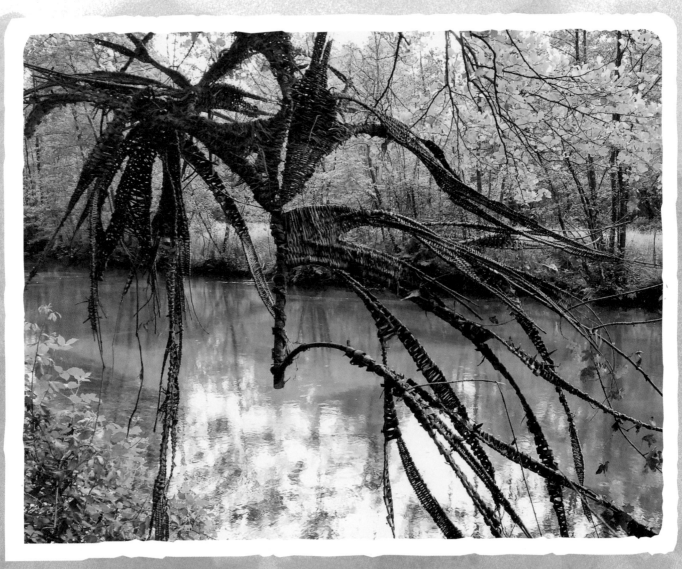

Land art lives outside and is made from "outside." Hangy thingy,
Nick Neddo and Hannah Mitchell, Polcenigo, Italy.

LAND ART

If you have ever made a doodle, design, or sculpture outside with natural materials you picked up on the spot, you might be a land artist. Land art is also known as "earth art" or "earthworks." It's the creation of art forms (often sculptures) made directly in (and with) the landscape, and it's created with local natural materials such as soil, sand, rock, leaves, or twigs. It is site specific: the place where it is made is a big part of the art.

Art historians might tell you that land art is an art movement that came out of the United States in the 1960s. But anyone who has seen the Great Serpent Mound in Ohio (made by the ancient mound-builder civilizations) might disagree. This giant sculpture was built about 2,300 years ago by the Adena culture (a pre-Columbian Native American society), famous for their intricate earthworks.

Think about how natural it is for human beings to make things with our hands, and how long we have been picking up sticks and stones. It seems like we have been "land artists" for a very long time.

PROJECT ⁚ 37 ⁚ EARTH ART MOBILES

CHALLENGE LEVEL

MATERIALS

• 3 sticks (for the rods)
• 4 nature treasures (pine cones, for example)
• String

TOOLS

• Pruners
• Scissors

Mobiles are hanging sculptures that move freely in the air's invisible currents. They use the principles of weight, movement, and balance to create cool special effects. The materials to make a mobile can be put into three categories: rods, cords, and interesting objects. The rods and cords are often somewhat invisible structural pieces, with the cool objects being the main attraction. Each rod usually hangs from its center by a single cord and has something hanging from both ends: another rod on one end and a cool object on the other end.

Mobile art has been around since people started making wind chimes, but it wasn't until the 1930s that it was developed into its own remarkable form of sculpture. One artist in particular, Alexander Calder, spent his life making mobile art and inspired the world with new sculptural possibilities.

There are a lot of ways to make a mobile, but I'll show you just one of them for this project.

Mobiles are "kinetic" art forms; they are free to move around in their space.

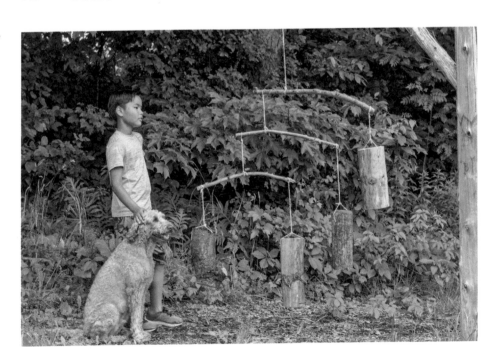

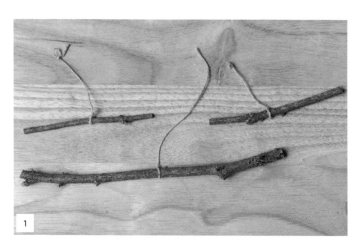

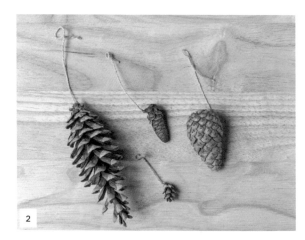

1: FIND YOUR RODS

This project uses sticks for the rods. Gather three sticks that are all slightly different in length. Make sure they are not weak or rotten. This will be a smallish mobile, so pick sticks that are about as big around as your thumb.

2: FIND NATURE TREASURES

This mobile needs four interesting objects from the natural landscape. They can be four of the same type of thing, or they can each be different. Keep your eyes out for feathers, bones, cool sticks, seashells, rocks, pine cones, panels of bark, antlers, seedpods, and anything else that you want to be part of your sculpture. Use pruners to cut what you need.

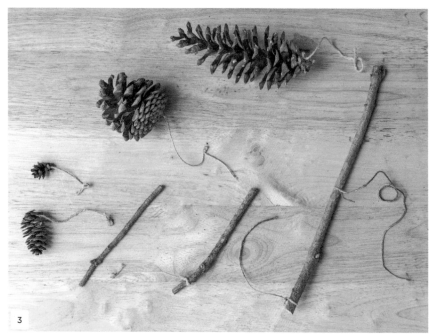

3: TIE THEM TOGETHER

Tie your nature treasures to the end of a piece of string, about 1 foot (23 cm) long. Now tie about 2 feet (46 cm) of string to the center of each stick, except the smallest one.

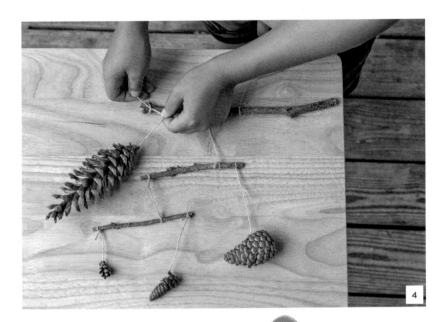

Mobile artists play around with weight and balance to keep each of the rods mostly horizontal.

TIP: When you tie the string to the rods, use a knot that you can easily untie at first (like tying your shoes). This will make it easier to adjust each string so you can place things just right. When you like where things are, use a tighter, more permanent knot.

4: PUT IT ALL TOGETHER

Each rod will have two things hanging from it. On one end, tie one of your nature treasures. On the other end of that same rod, tie one of your other rods. Use the string that you attached to its center. Do this with each of the rods until you have just one left. The last rod will get two nature treasures, one hanging from each end.

5: HANG YOUR MOBILE

Now that it's all tied together, it's time to hang it up and make some fine adjustments. If you want it to live outside, find a branch from a tree to hang it from. Tie the top rod around a sturdy branch with the string attached to its center. If you want the mobile to live inside, find a secure way to hang it so it doesn't fall down!

TIP: You might want to use a stepladder to carefully reach the best place to hang your mobile.

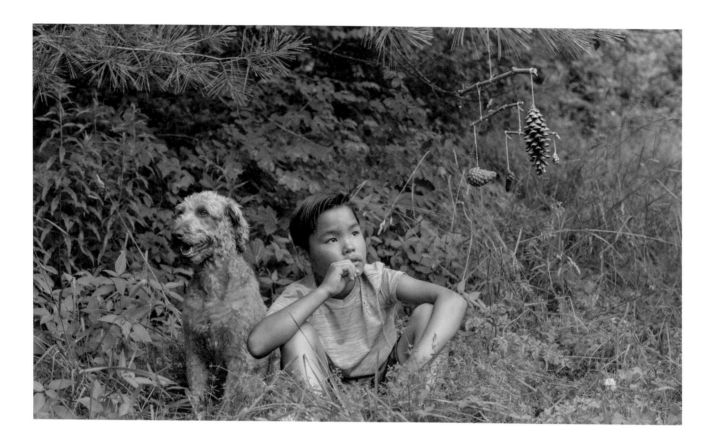

6: BALANCE THE RODS

Now that the mobile is hanging you can see whether the rods are balanced. A rod is balanced when it hangs horizontally (instead of diagonally). Most likely, you will need to make some adjustments. Start at the bottom rod. If it needs adjustment, play around with where it is tied (near the center). Move the tie away from that spot until the rod hangs level. Do this with each rod from the bottom to the top.

Playing Around: Mini Mobiles

How small can you make a mobile? What if you made a mobile, but in place of individual nature treasures hanging from each rod, you hung mini mobiles instead?

What if you made a mobile almost completely out of leaves? What if you used some of your handmade paint to add your own color to them first?

What if you made a mobile with more than three rods?

That would be so cool!

PROJECT ⁘ 38 ⁘ EARTH ART ASSEMBLAGE

Assemblage is the three-dimensional version of collage. Instead of using flat, cutout images glued together to make a collage, you use found objects of all different shapes and sizes to make an assemblage. Some assemblages are freestanding sculptures made of different connected items, some are made by gluing things to a flat surface, and others are made inside boxes that hang on the wall. This project uses special treasures from nature that you can find outside in the wild places near your home. Your "canvas" will be a flat piece of ground.

One of the beautiful things about making earth art assemblages is that you don't need any special tools or materials to do it. The nature of this kind of art is that it is temporary. A gust of wind could come and change the whole thing, and that is just fine! This project helps remind us to enjoy the act of being creative and not be too attached to the outcome. When you make an earth art assemblage, you partner up with the greatest artist of all, Mother Nature.

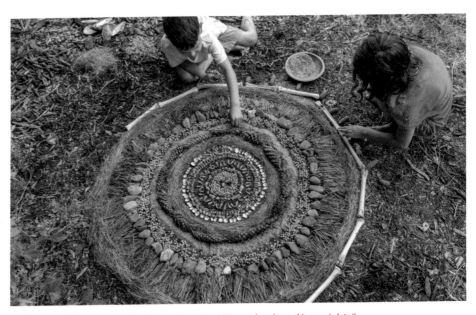

Earth art assemblages can be made spontaneously or they can be planned in great detail.

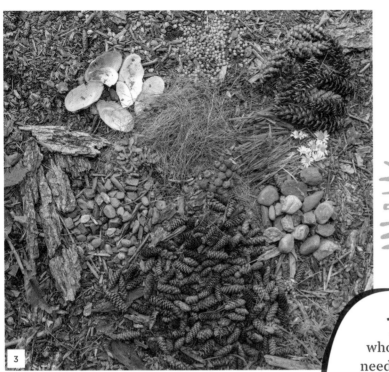

3

1: FIND YOUR TREASURES

Go somewhere where you can find interesting nature treasures, where you can collect at least a couple handfuls of each thing. Think of this as a painting, except your colors are "nature treasures" instead of paint. If you only have one of any particular nature thing, it's like only being able to make one brushstroke of that color with your paintbrush. So bring a bag and collect sets of things, such as blades of grass, tiny pebbles, seeds, stones, dead twigs, acorns, leaves, sand, seashells, soil, feathers, whatever you can find that is interesting to you. The more selections you have, the more "colors" you can "paint" with!

TIP: Please don't pull up whole plants for this. There is no need to kill a plant for this project. Only use flowers if there are a lot of the same species living there. There are a lot of endangered flowers that are beautiful works of art just as they are.

2: PICK YOUR SPOT

Choose a place to work and then give your assemblage "canvas" a shape. Place sticks in a rectangle or square outline (like a regular piece of paper) or make a circle or another shape out of any other material you want. The inside of that shape is where you will make your assemblage.

3: SET UP YOUR PALETTE

Make piles of all the different objects that you collected. Put them off to the side where you can see them and easily reach them. This will help you make creative decisions as you work.

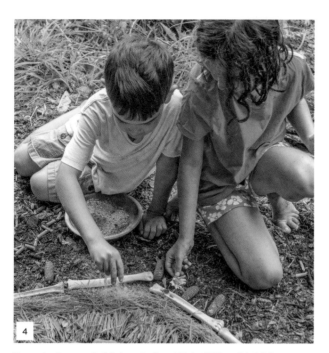

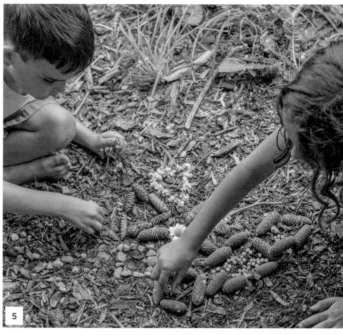

Use each of your materials to make lines. Think of it like a "sketch."

Experiment with how to arrange your materials to play with their colors and textures in your design.

4: MAKE LINES

Play around with each special thing you collected. Make each of them into different kinds of lines by setting them up in a row. Some things will make thin lines if they are arranged a certain way, and thick lines if they are set up in a different way. These lines can squiggle, bend, swoop, zigzag, or be straight—it's up to you! Use pruners if you need to cut your materials.

5: MAKE SHAPES

Now, make some of those lines into shapes (maybe circles with one material, triangles and squares with others). Use each of your nature treasures to "color" inside those shapes. Fill the whole space inside your "canvas" with the materials you collected. If you need to make your canvas bigger, no problem. Part of the fun is experimenting, so play around with different patterns and designs!

Make Your Own Rules

Remember that an assemblage doesn't have to be flat like a painting. You can make one that has groups of things stacked up or sticking out of the ground. You can build your assemblage into a sculpture that is as tall as you are. And who says you have to build it on the flat ground? You can make an assemblage on the side of a tree or rock face if you want. You are the artist and you can make up your own rules!

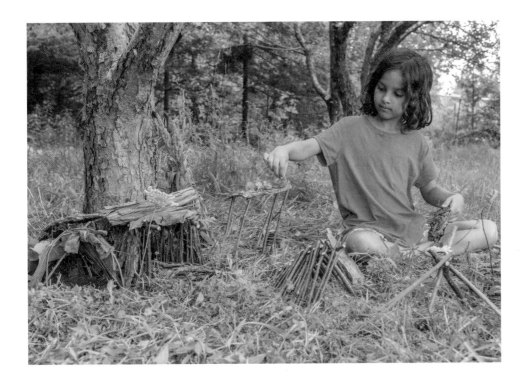

Playing Around: Faery Houses

A faery house is basically an earth art assemblage that a little faery can live in. The only requirement is that it has some walls and a roof. Think of it like "nature Legos." Legos are cool, don't get me wrong, but nature Legos are way better. Each piece has its own unique shape, size, color, and texture, they're free, and you get to find all the pieces yourself! Every spot on the landscape is special and interesting, and offers the faery house builder a custom set of nature Legos.

I love these for so many reasons:

• They are super cute and cool.

• They represent some of the most pure and natural examples of childhood creativity and ingenuity.

• They teach how to solve important engineering problems.

• They are fun to make for all ages.

• They can be simple or super elaborate.

• They get you directly interacting with nature on both a creative and an analytical level.

In fact, I think it would be good for the world if more adults made faery houses too. Go ahead, you dusty old grown-ups, I give you permission.

ACKNOWLEDGMENTS

Thanks to all the kids I have worked and played with in the last twenty years. You have been the real teachers. Endless gratitude to our ancestors, whose profound relationships with life on Earth have carried us to the present moment. Sincere respect to the indigenous peoples and tribal communities throughout time and around the world. It is you all who offer modern humanity a road map back to true civility and ecological sanity. Heartfelt thanks to the friendship of moths, snakes, and pine trees. Endless gratitude to my other teachers: all the critters mentioned in this book and beyond. Sincere thanks to all the families who volunteered to be part of this book! Huge thanks to Sarah Shapiro, my sweet partner in this life. Your support is unrivaled. Thank you for your persistent patience and appreciation. Thanks for proofreading and editing. Thanks for humoring (and honoring) my creative eccentricities and tolerating my "special projects" all these years. Big thanks to Carolyn and Andy Shapiro for their big, beautiful hearts and multifaceted support. A big word of thanks to my parents for encouraging me to explore my creative potential as a kid. That's huge. And to my grandmother, Irene. Mother Earth, thank you for giving us our lives and graciously caring for us, despite it all. Gratitude to the Great Mystery and the Sacred Question for keeping me curious. Oh, and thanks to Amber's pizza. You supported me from the beginning of the very end.

ABOUT THE AUTHOR

Nick Neddo, author of *The Organic Artist*, has been making art since he could first pick up a crayon. He grew up exploring the wetlands, forests, and fields of his bioregion and developed a profound curiosity, respect, and love for the landscape. As a youth, Nick identified primary focuses that would become life-long pursuits: study of the natural world, Stone Age technology/primitive skills, and creating art. Trusting the inherent value of these pursuits, he continues to embrace his role as a lifelong student, with a ravenous appetite fueled by a genuine love of nature and the creative process. His travels are compelled by prehistoric art sites and the pursuit of wildness, seeking traditional skills and experiencing the landscape's majesty, which are common themes in his artwork.

Nick has been teaching primitive skills, wilderness survival, tracking, drawing, and nature awareness professionally since 2000. You can find his latest artwork, workshop schedule, and other creations at www.nickneddo.com.

INDEX